Private Places

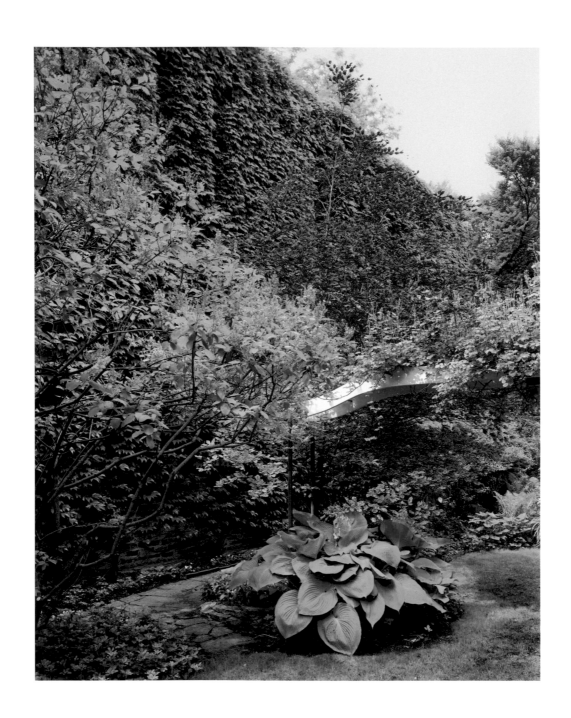

Private Places

Photographs of Chicago Gardens

by Brad Temkin

with an introduction by Rod Slemmons

Center for American Places
Santa Fe, New Mexico, and Staunton, Virginia

in association with
Columbia College Chicago

PUBLISHER'S NOTES: *Private Places: Photographs of Chicago Gardens* is the seventh volume in the series *Center Books on Chicago and Environs*, created and directed by the Center for American Places with the generous financial assistance of the Graham Foundation for Advanced Studies in the Fine Arts. The book was brought to publication in a clothbound edition of 2,750 copies and a limited clothbound edition of 100 signed copies casebound with an original print, with the generous support of Patrick and Susan Frangella, Columbia College Chicago, and the Friends of the Center for American Places, for which the publisher is most grateful. For more information about the Center for American Places and the publication of *Private Places: Photographs of Chicago Gardens*, please see page 70.

The Center for American Places, Inc.
P.O. Box 23225
Santa Fe, New Mexico 87502, U.S.A.
www.americanplaces.org

Distributed by the
University of Chicago Press
www.press.uchicago.edu

9 8 7 6 5 4 3 2 1

Library of Congress Cataloging-in-Publication Data is available from the publisher upon request.

ISBN 1-930066-41-4 (clothbound)
ISBN 1-930066-42-2 (limited edition)

Contents

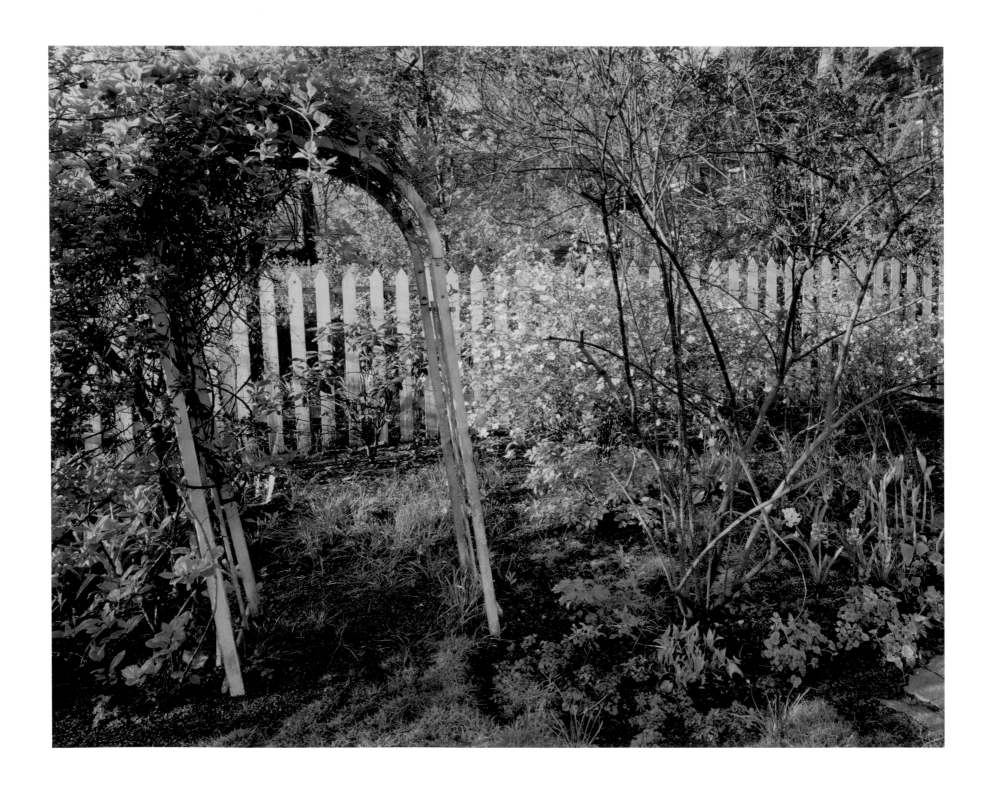

Green Thoughts

Rod Slemmons

THE GREATEST PLEASURE of Brad Temkin's *Private Places* is that we get to see a lot of other people's gardens in a short time. Most of us carry around in our memory a collection of past and present gardens, others' and our own, that we have built slowly over the years. And we might have a small stack of photographs of our attempts to bend nature to our vision of order or disorder. Living in the damp fecundity of the Northwest for so long, my main memories entail trimming, pruning, and clearing out one set of plants to remove the shade from and nurture another. These were mostly Shakespearean gardens verging on Joyce—just barely under control. My artist-wife claimed small areas for orderly flowers and vegetables, while I was inclined to see how big the native plants could get before they fell over. The gardens in *Private Places* slide on a spectrum between these two positions. I used to think of this as

the difference between cultivating the Tree of the Knowledge of Good and Evil and watching the Tree of Life become rampant, but it is probably closer to recreating Eden in Wildness beyond its walls.

Another pleasure of Temkin's typology of Chicago gardens and backyards, where life outside for plants and humans can be difficult in extremes, is to enjoy them in the context of the general history of gardens and parks, poetic and real: Eden and Gethsemane; the Hanging Gardens of Babylon; the bizarre topiaries of Versailles; Voltaire's retirement plans; spare, Japanese temple rock gardens; Central Park and all the other Olmsted creations; Giverny; and Robert Irwin's huge, contemporary Central Garden on the hilltop at the Getty Museum in Los Angeles, in his words, "a sculpture in the form of a garden aspiring to be art." All of the gardens in this sampling

of ambitious cultivation are intended to be instructive metaphors about our place in nature, while at the same time affording opportunities for various combinations of solace and awe. While most of the backyard gardeners are following smaller, conventional urges they may barely be aware of, or are just simply making it up as they go along, some have clearly spent time with garden magazines and money at the local garden center, so that their gardens are interchangeable with many others. They have acquired a relationship with nature. But all of the urges, obeyed by the designers of the gardens at Versailles or by Monet as he transformed a creek and farm field into his creation at Giverny, have been felt at one time or another by the keepers of Temkin's backyard collection.

Another element to these pictures widens their metaphoric possibilities: Parallel to the range of plants in them, from the hybrid and subtly fragile to the recognizably rough and tumble, is an array of peculiar objects. Some are real art, like the ceramics of Ruth Duckworth (pages 18 and 19), and may have been made at least in part for supplementing the plants of her garden. Most of the others are not art. There is a style of gardening, recorded here, that requires that the tools of the trade always be in view, as if to say, "I am responsi-

ble for all this and work hard at it every day." Another style, also seen here, follows the convention of including objects that jar with plant life: peculiar Baroque or Victorian sculpture, wildly painted birdhouses, the now ubiquitous plastic chairs, and, in the most abstract example, large colored balls. Some of the gardens have paved walkways and paths that imply intentional viewing, order, and angle, and have as well tiny reflecting ponds. Some have rigidly geometric plots and others more organic, rambling beds.

In a few examples, Temkin has returned to the same garden for a second look. Here he is part of a tradition in the use of photography to understand time. Eugene Atget went back often to the parks and even the streetside trees of Paris to rephotograph, as if visiting old friends. In some cases he captured the yearly cycle of seasonal time—leaves coming and going; in others, the trajectory of the life of a single tree is seen—limbs cut or falling away, a trunk rotting. Mark Klett also observes the confluence of these two versions of time in his three rephotographic projects, repeating views made by photographers in the American West more than 100 years before him. Given that Temkin's backyard gardens are to some degree an analog or gauge of the gardener's trajectory of life as well as literal

evidence of the cyclic life of the plants, these repetitions on his part are nicely poignant and may also be a little disturbing in the sense that photographs serve as *memento mori*. In this light the photographs of decks or back porches, where the plants all live and die in pots, take on a different meaning.

Privacy and photography rarely appear in the same sentence. Temkin's *Private Places* gains strength from the fact that through his lens we have to sort out our inclusion in somebody else's privacy. The sense of order, or disorder, in these gardens and backyards is not ours. The absence of the creators of these places makes our minute examination of them a bit awkward. Our attempts to recreate their intentions not only put us in the position of spies, but also make us more observant, more aware, more tempted to compare what we see with the details of our own private places. By extension, Temkin's work addresses the core issue of photography as an expressive medium: It is neither seeing nor analyzing; it is a very selective record of a moment and a space. We can treat it like a memory or a poem, or raw information, but we can't treat it like knowledge, as in the Knowledge of Good and Evil.

We add knowledge to the photographs in this case by bringing to them our feelings about what it is like to create and spend time in these garden spaces, and about how they change us. As Andrew Marvell, in 1681, wrote:

What wondrous life is this I lead!
Ripe apples drop about my head;
The luscious clusters of the vine
Upon my mouth do crush their wine;
The nectarine and curious peach
Into my hands themselves do reach;
Stumbling on melons as I pass,
Ensnared with flowers, I fall on grass.

Meanwhile the mind, from pleasure less,
Withdraws into its happiness;
That mind, that ocean where each kind
Does straight its own resemblance find;
Yet it creates, transcending these,
Far other worlds and other seas,
Annihilating all that's made
To a green thought in a green shade.

— excerpted from "The Garden"

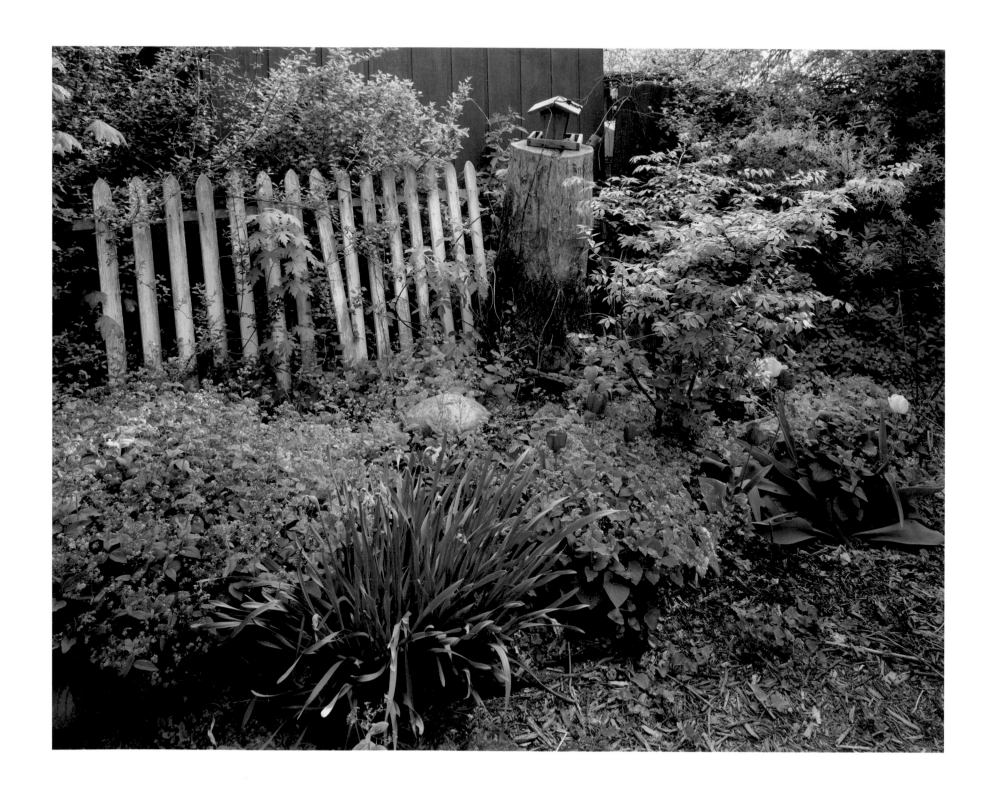

Private Places

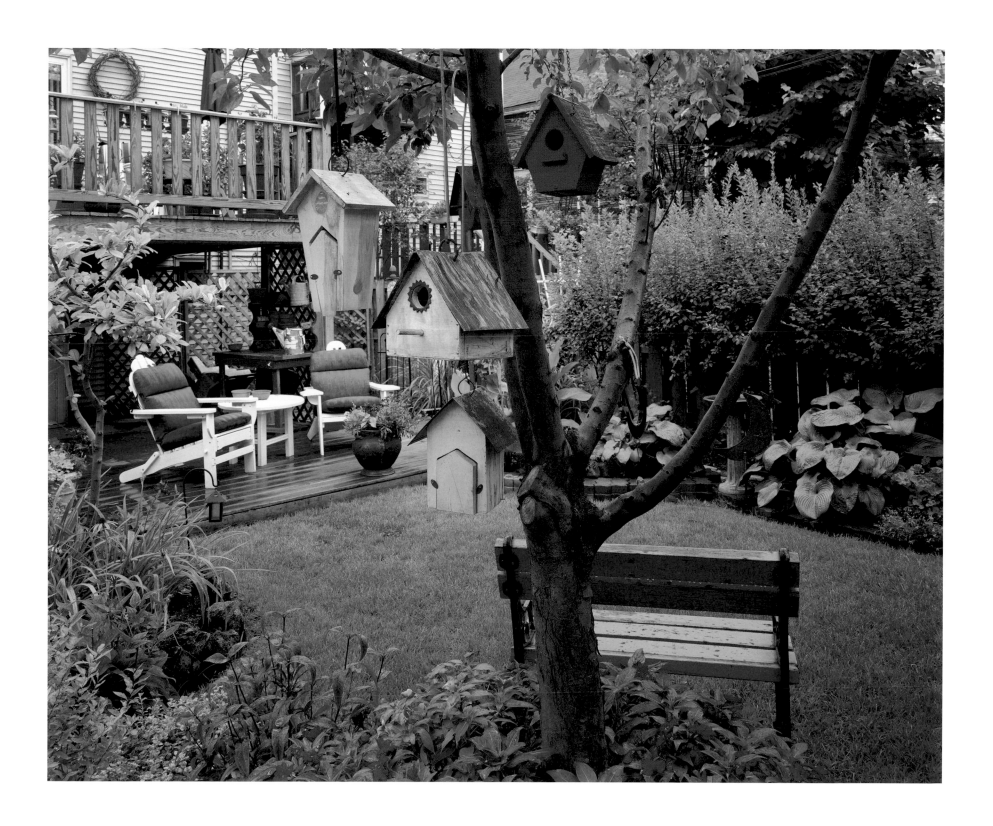

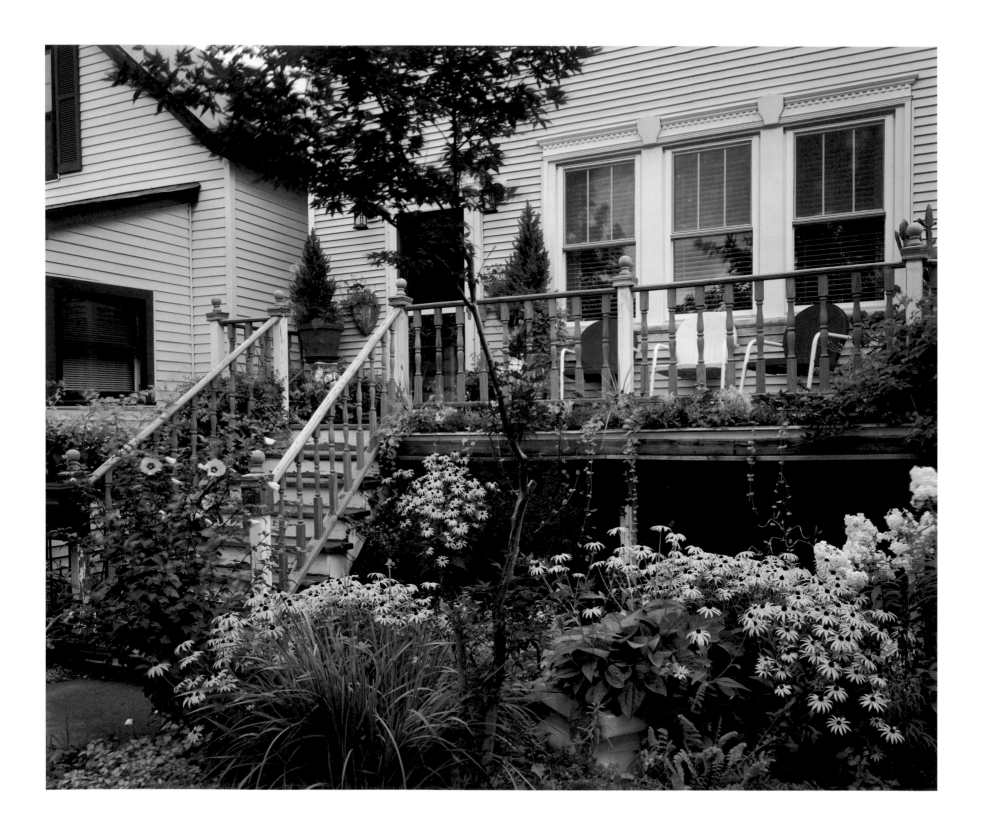

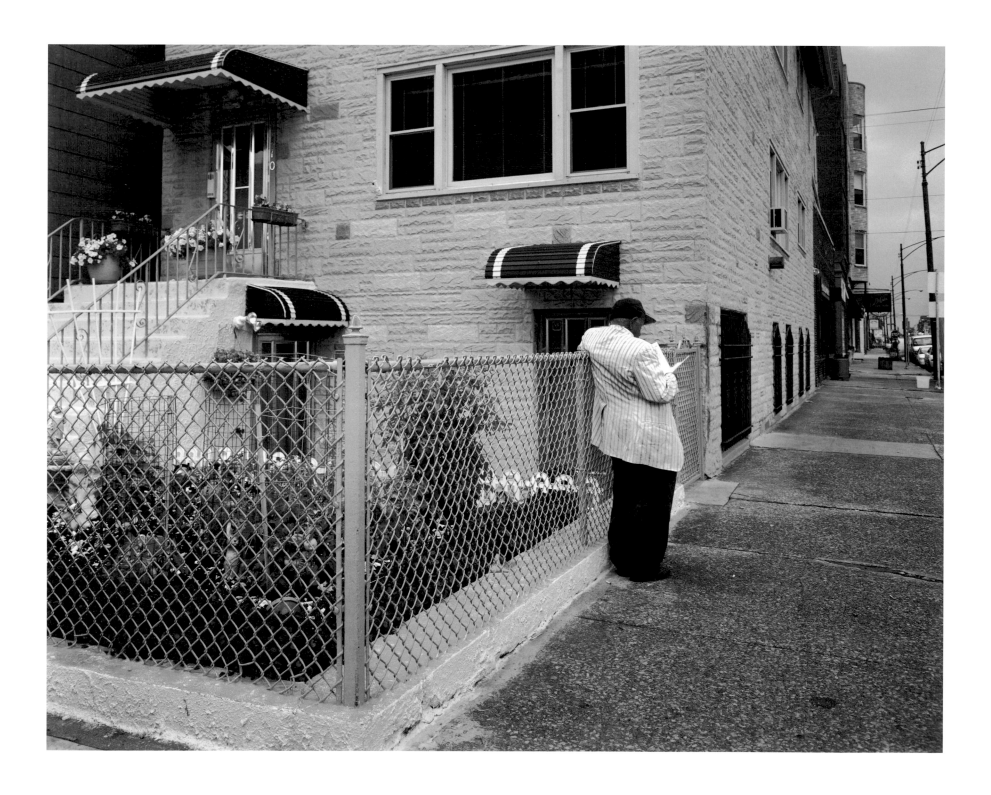

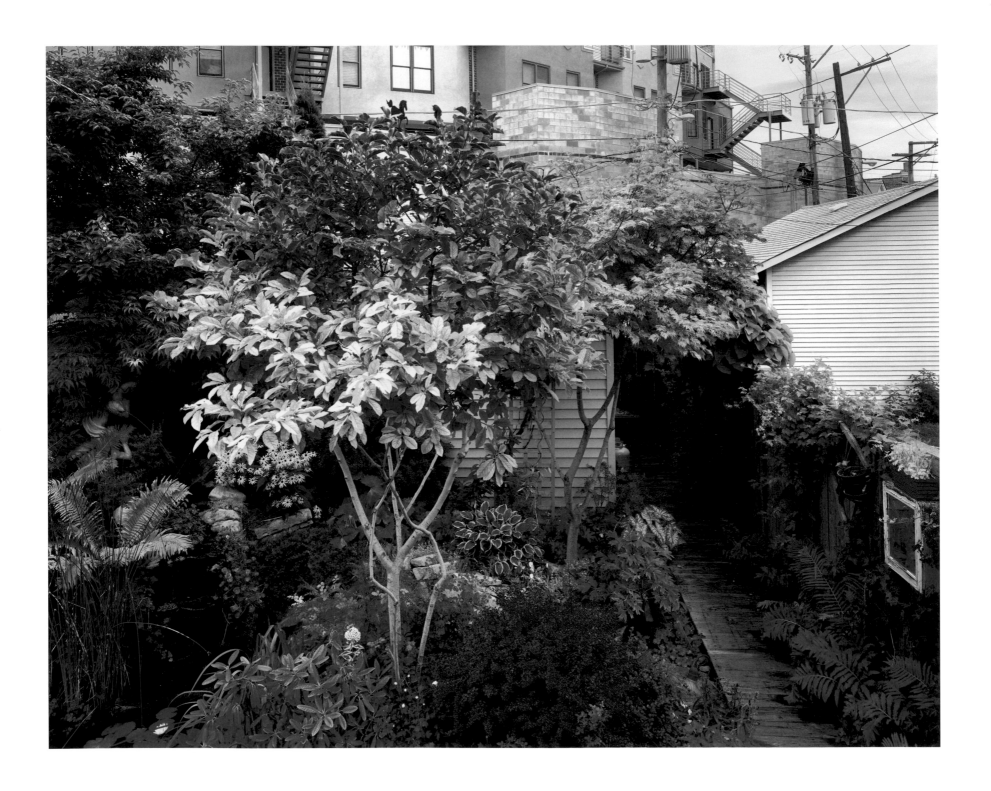

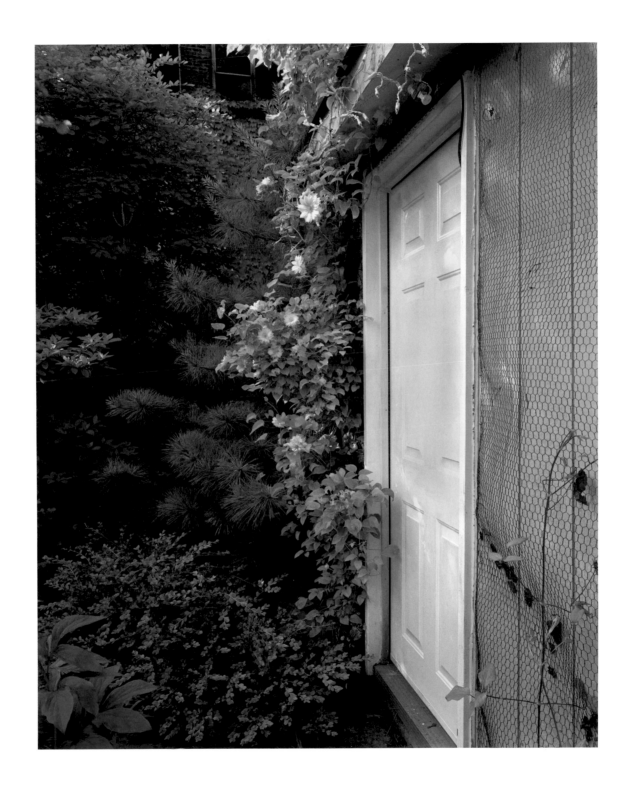

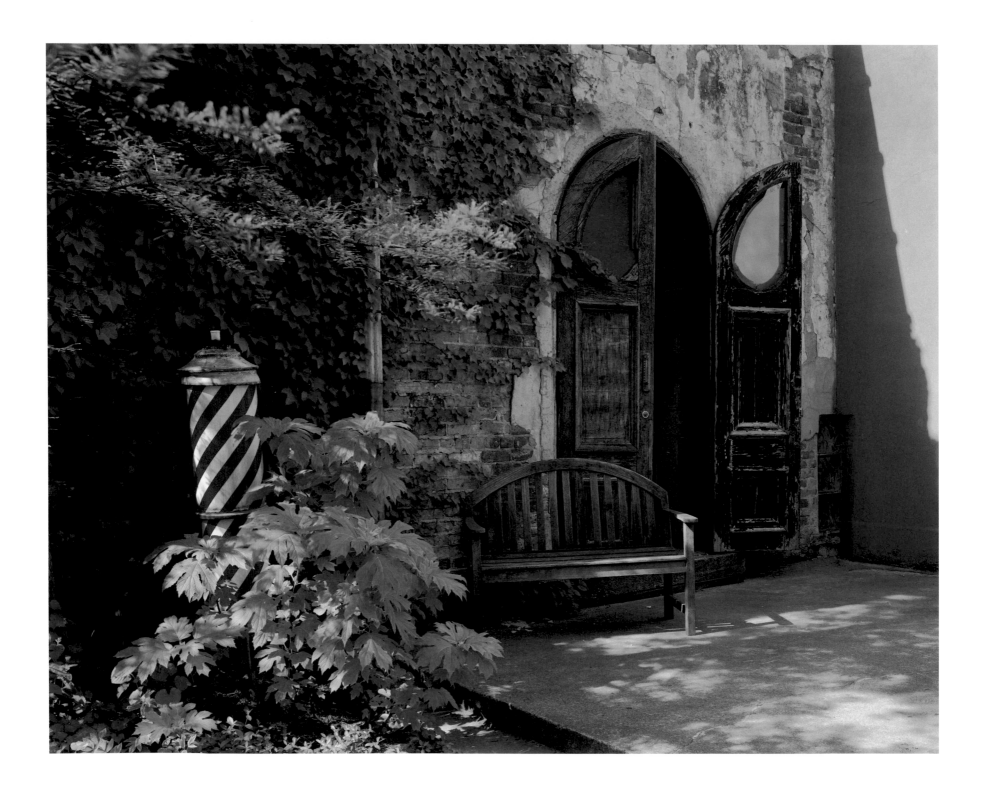

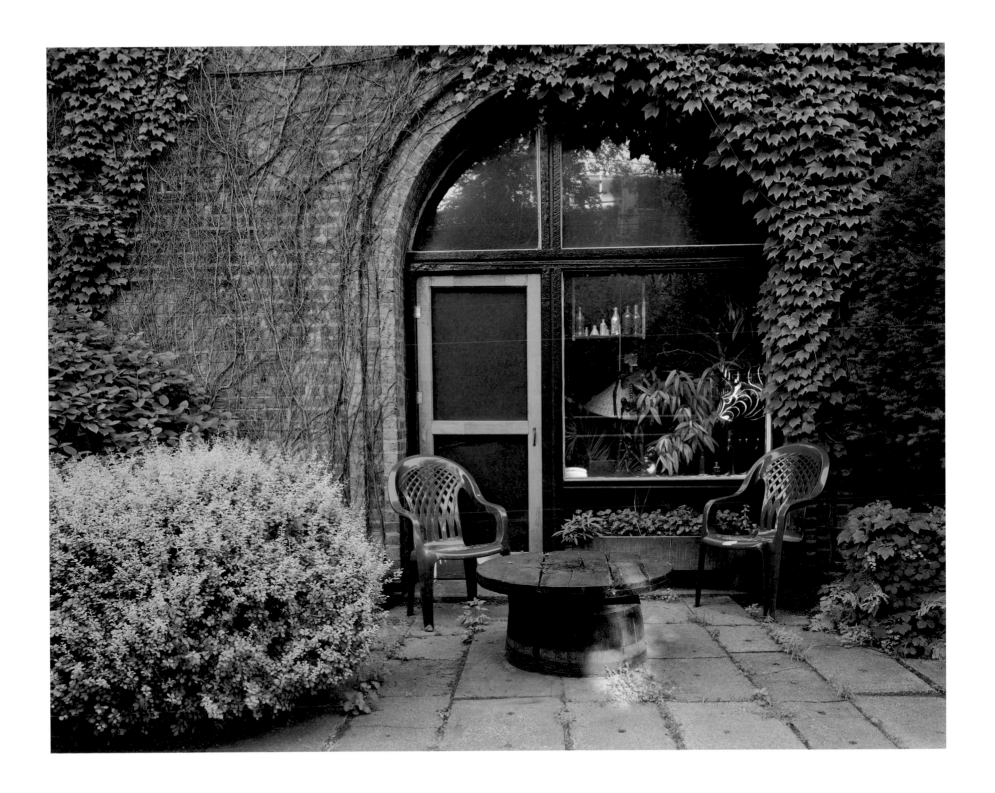

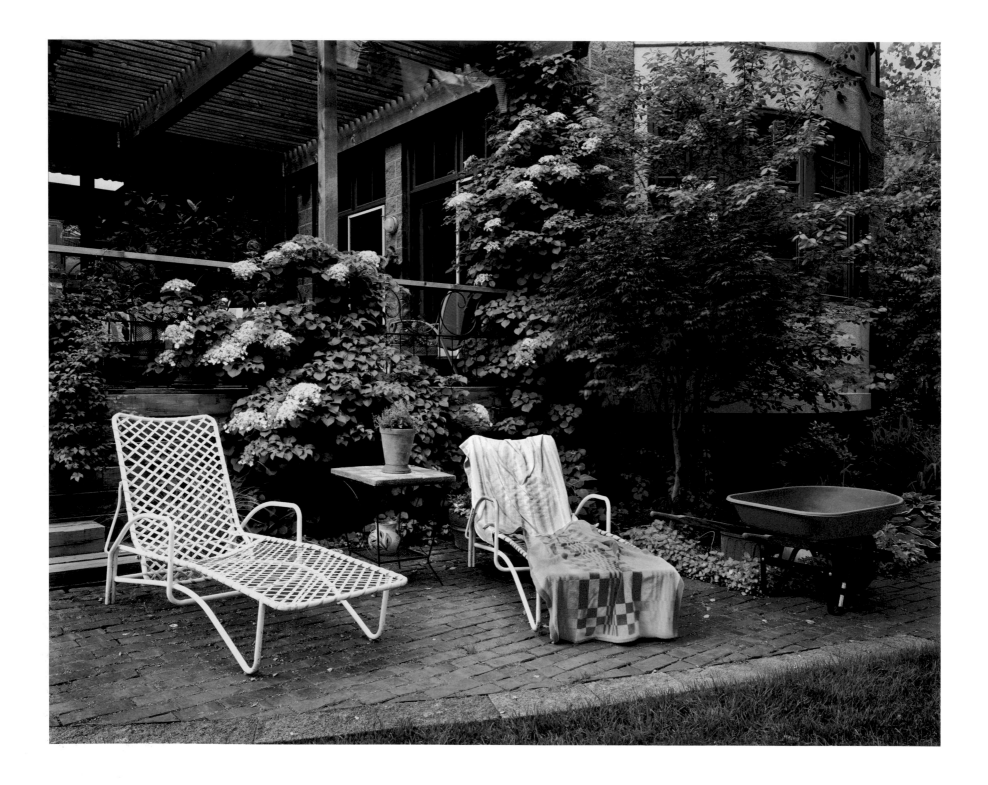

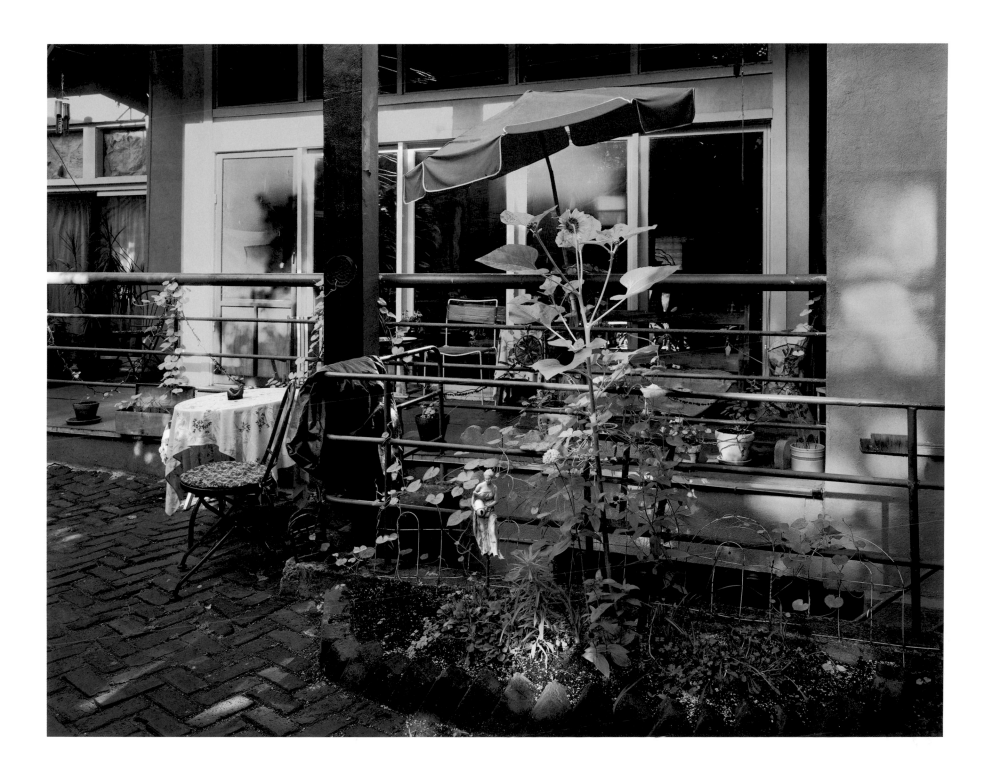

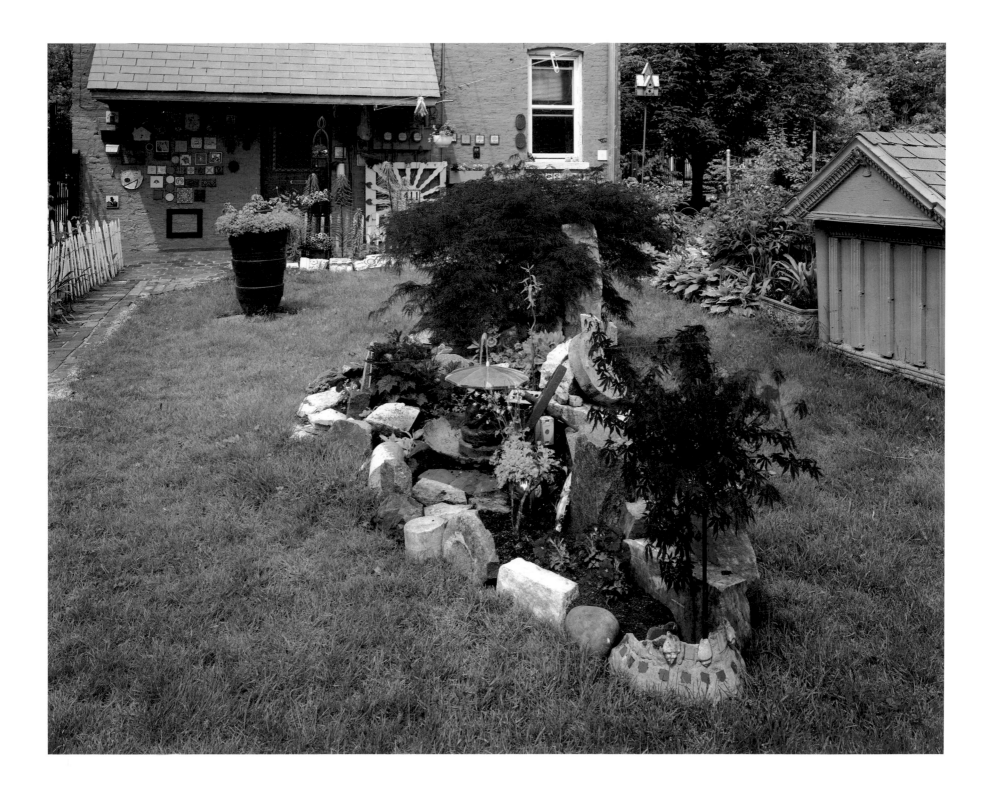

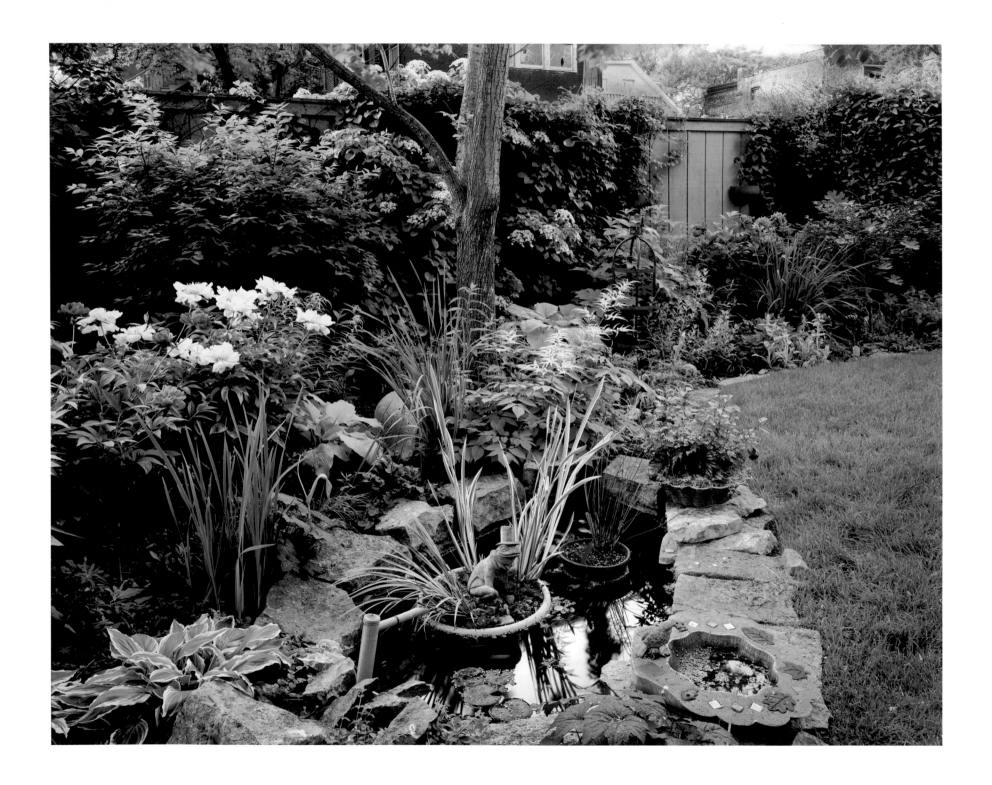

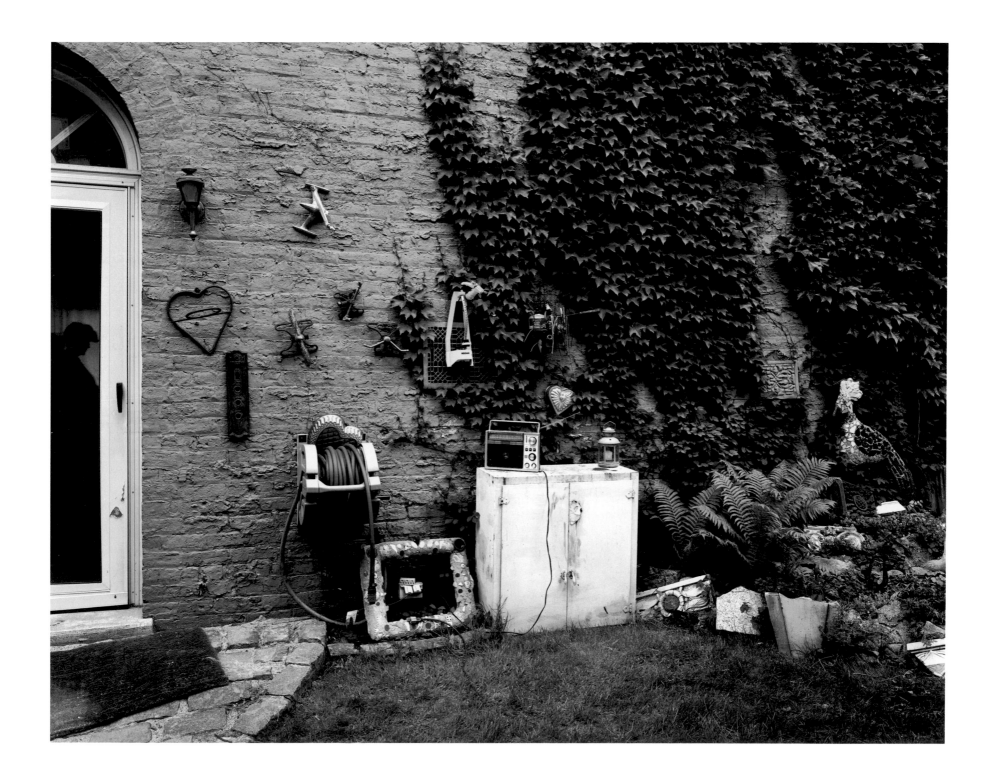

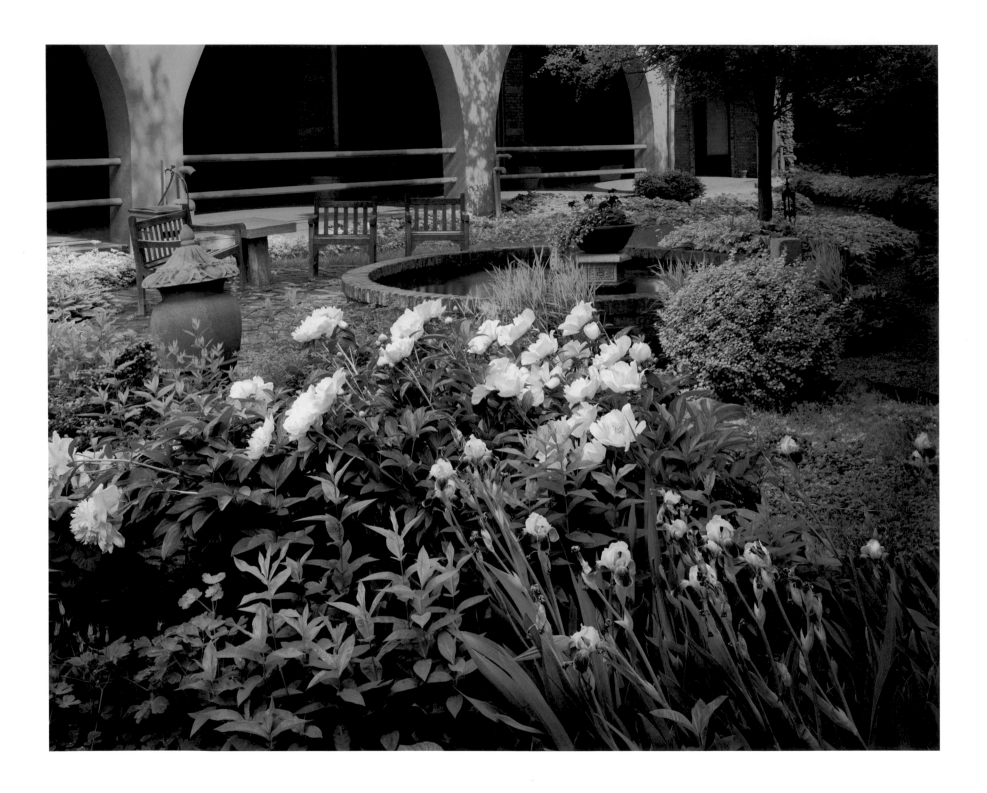

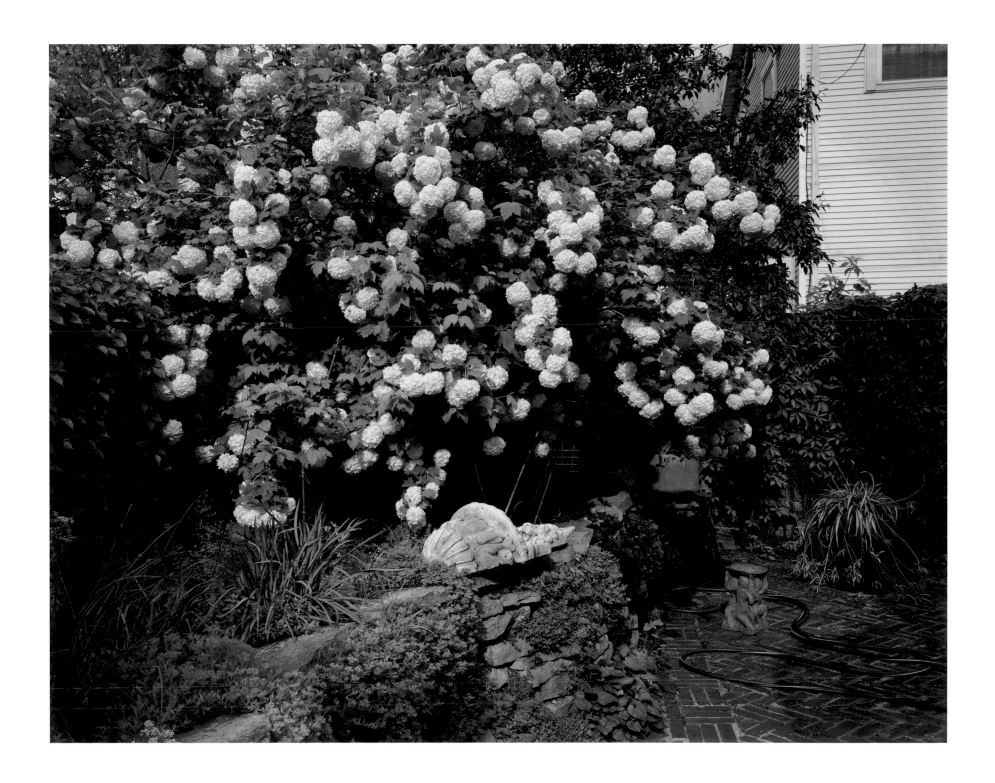

17

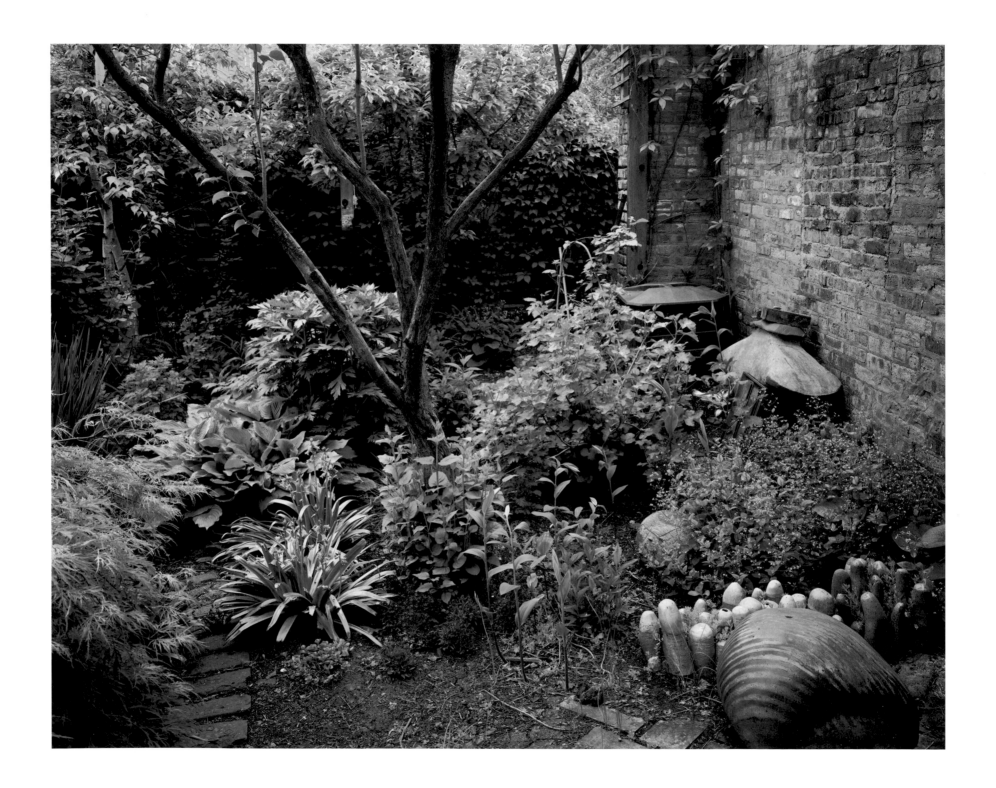

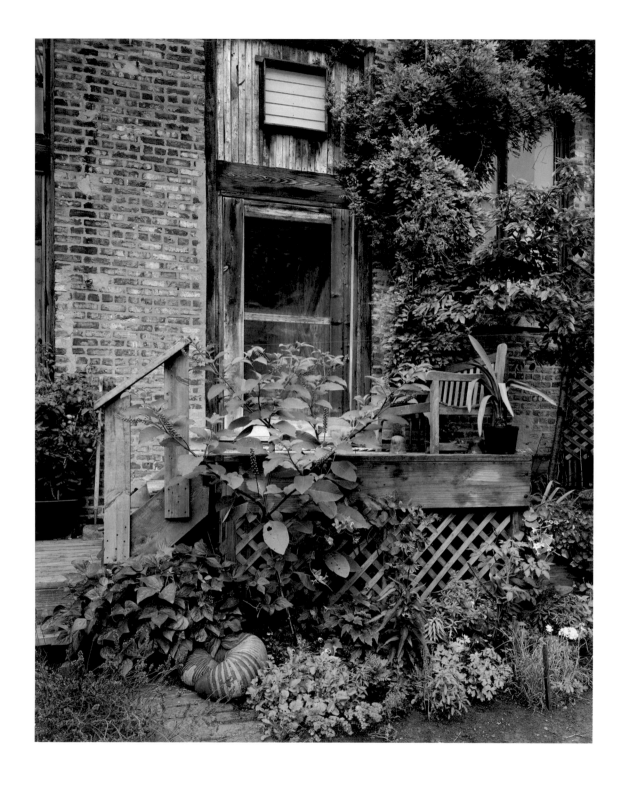

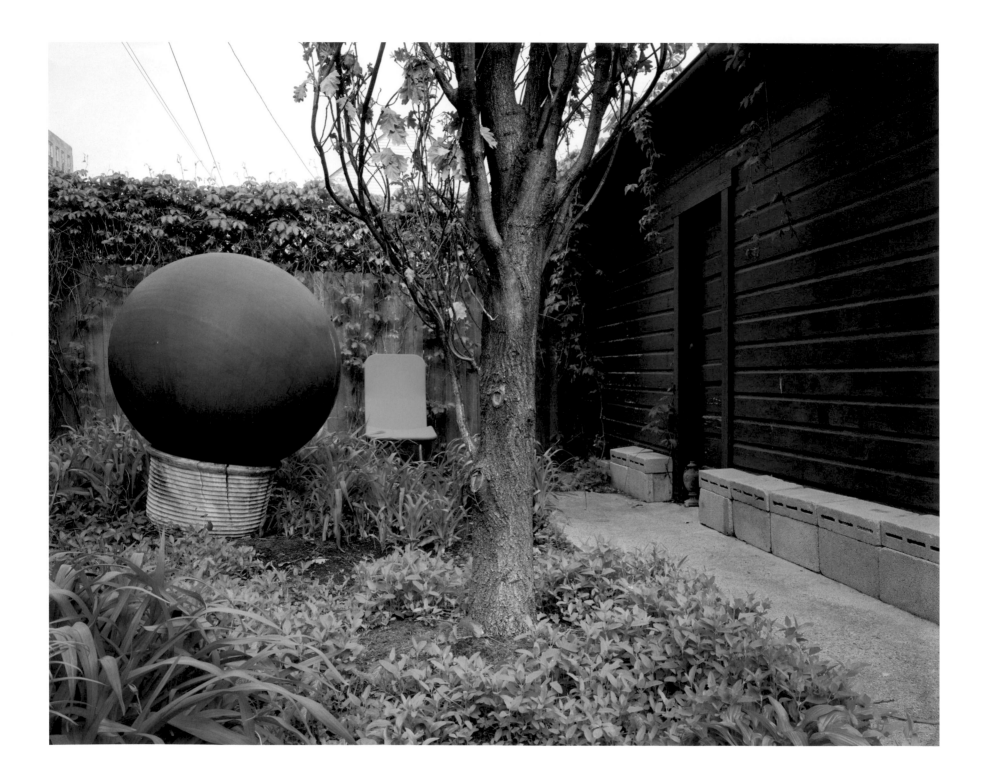

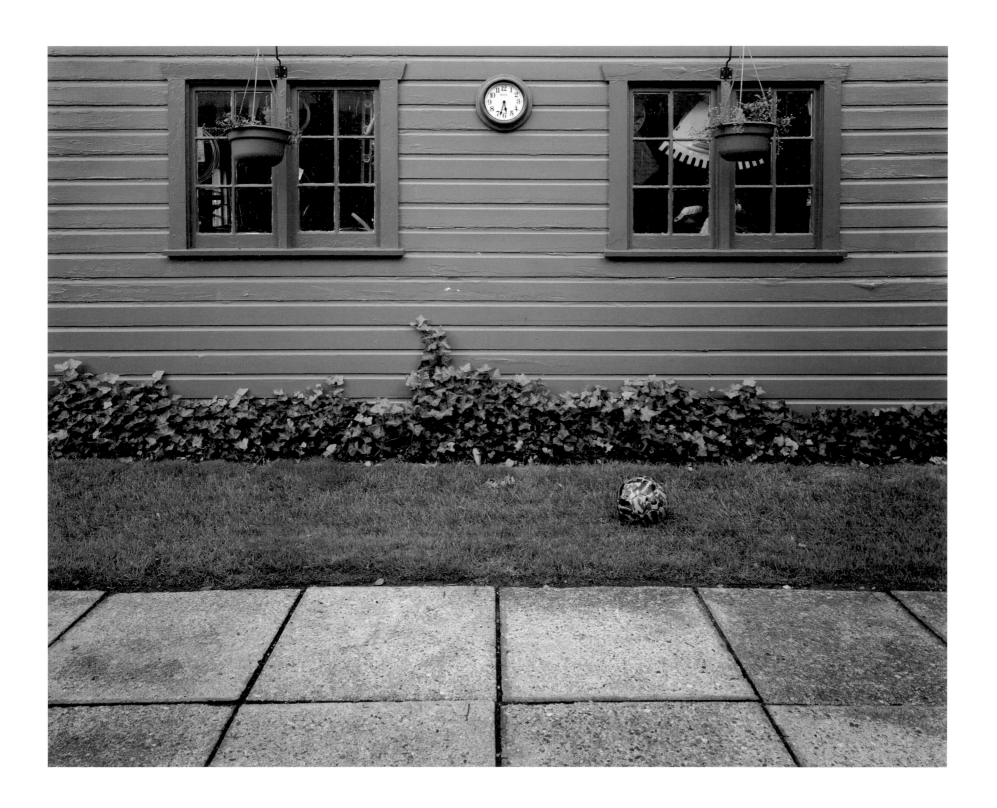

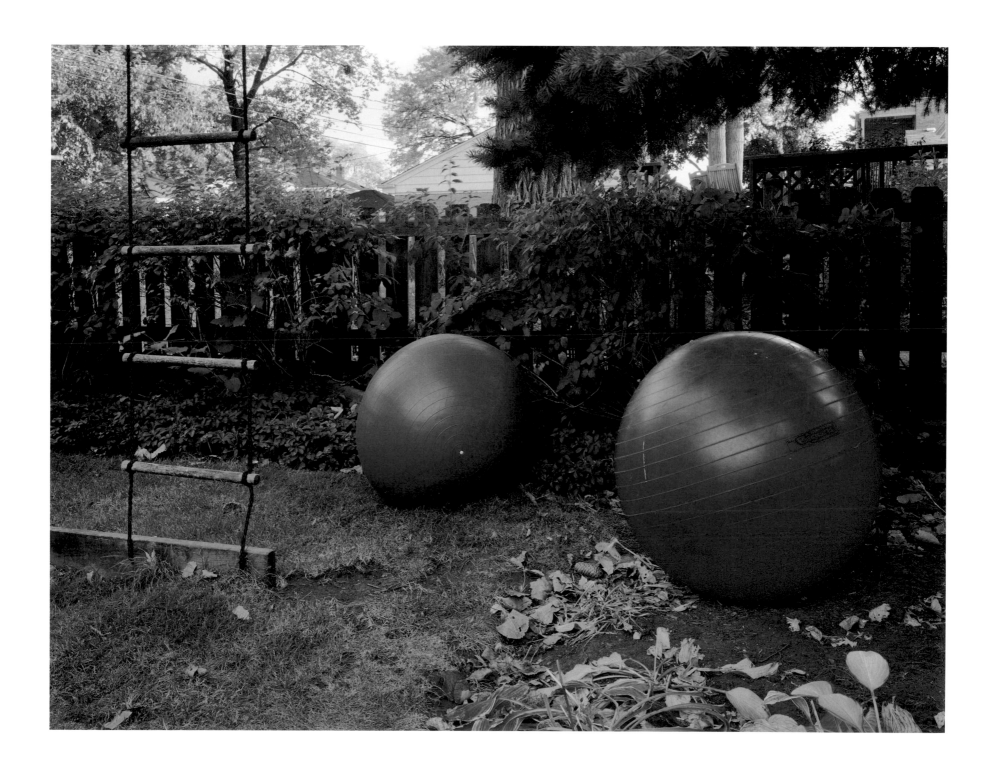

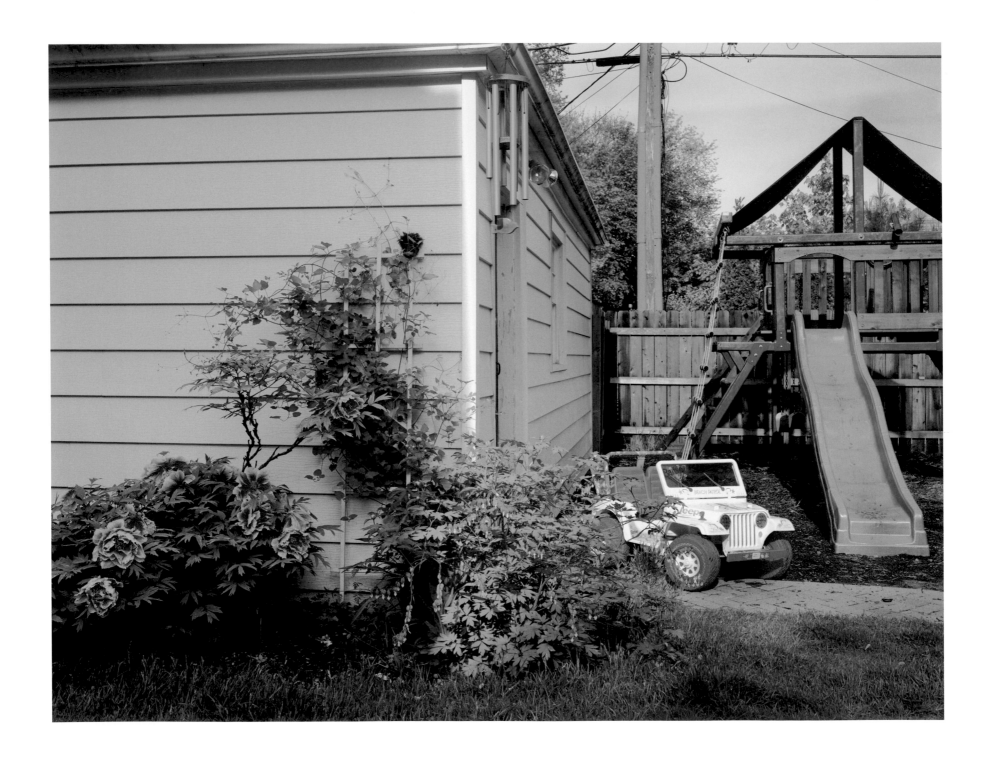

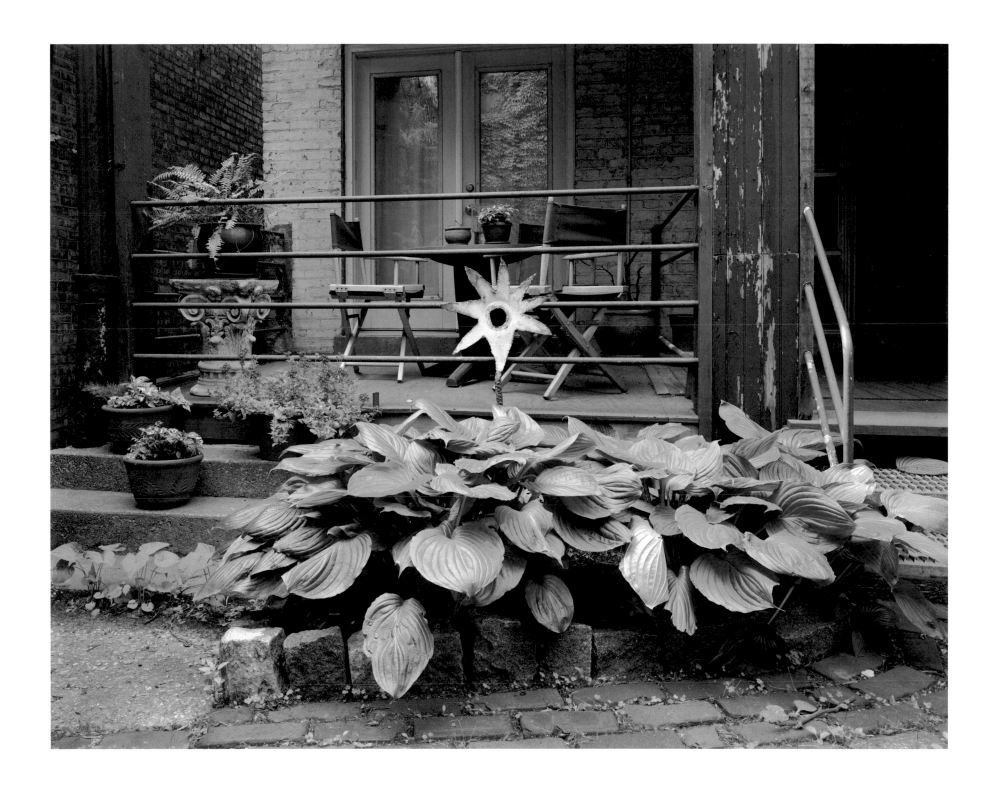

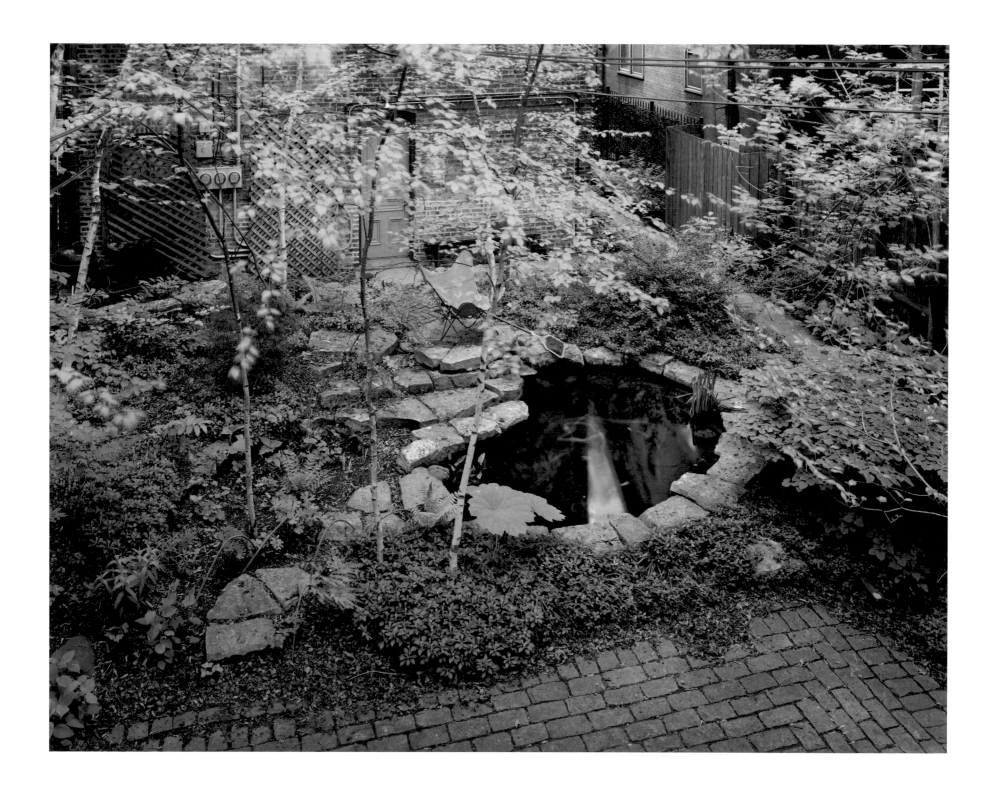

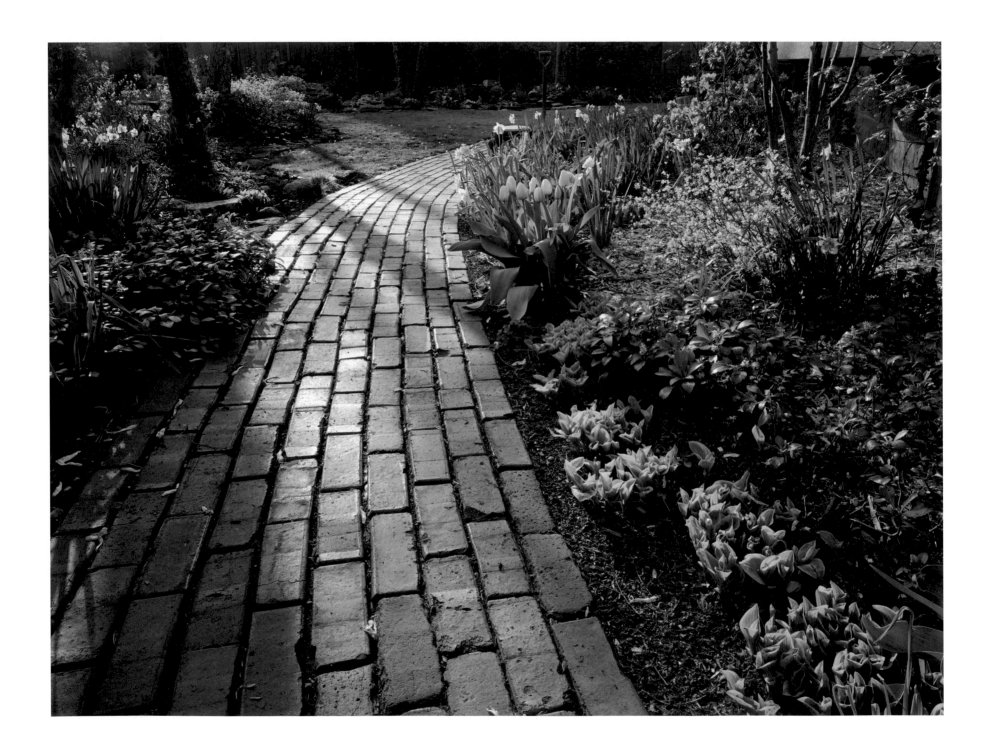

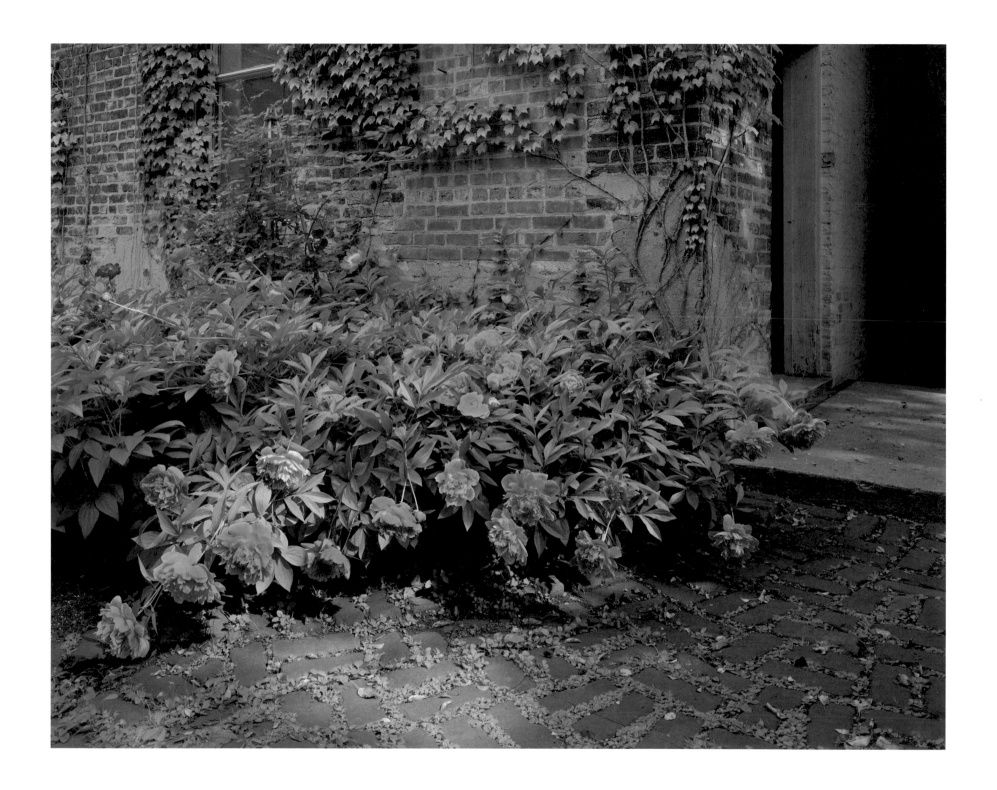

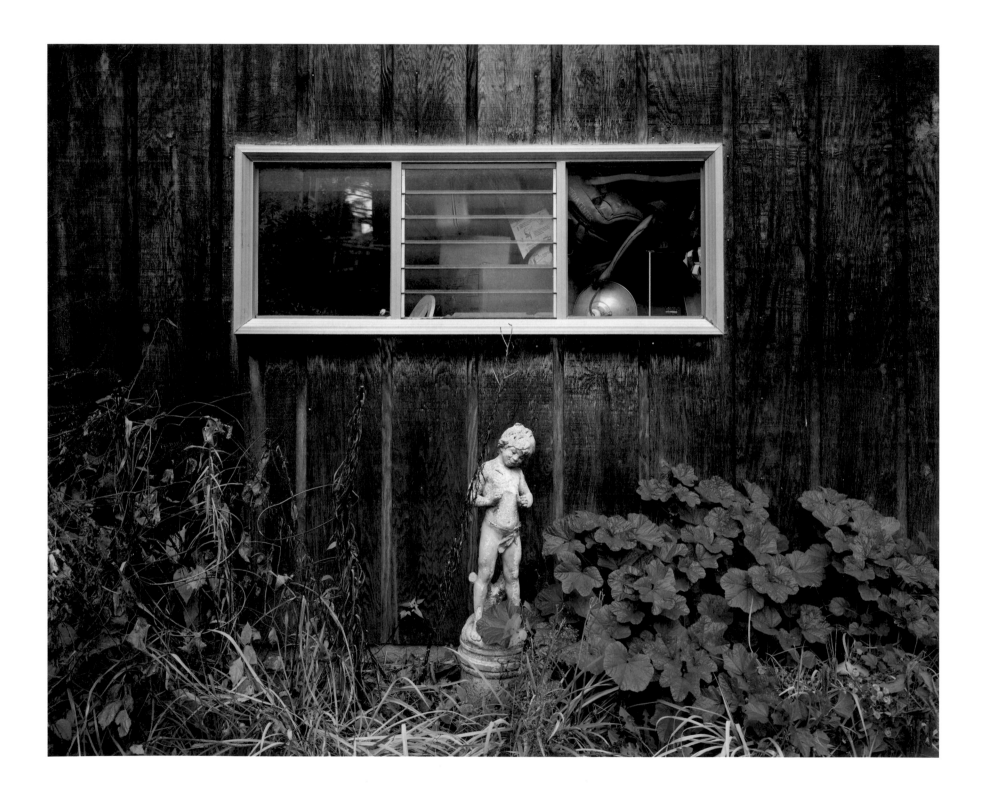

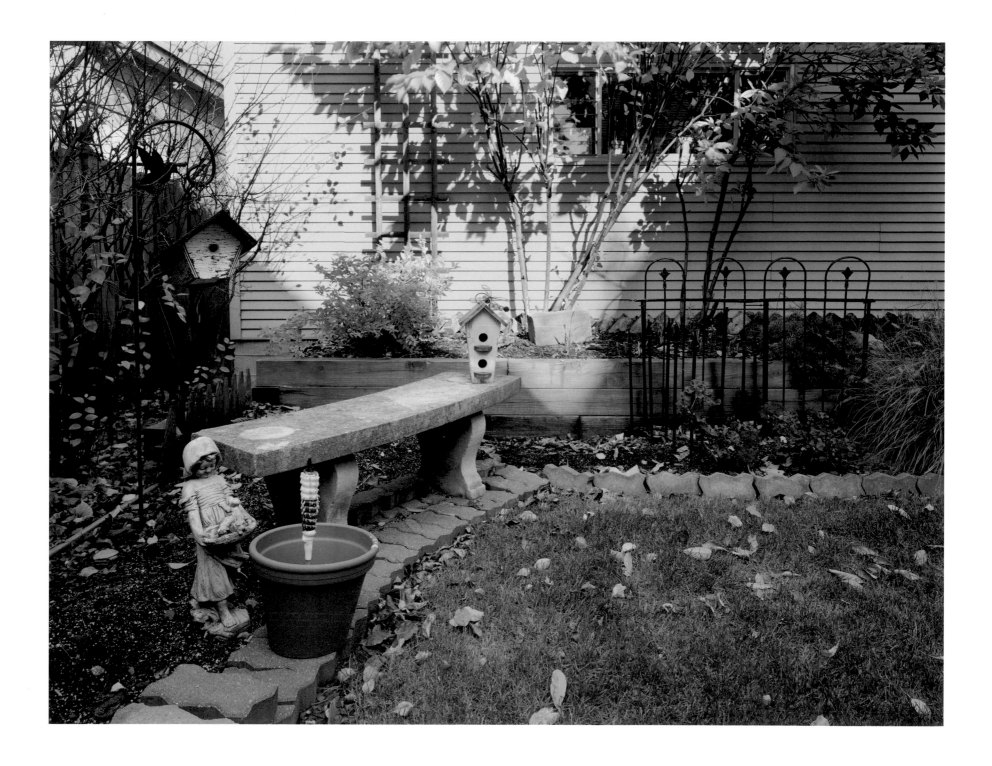

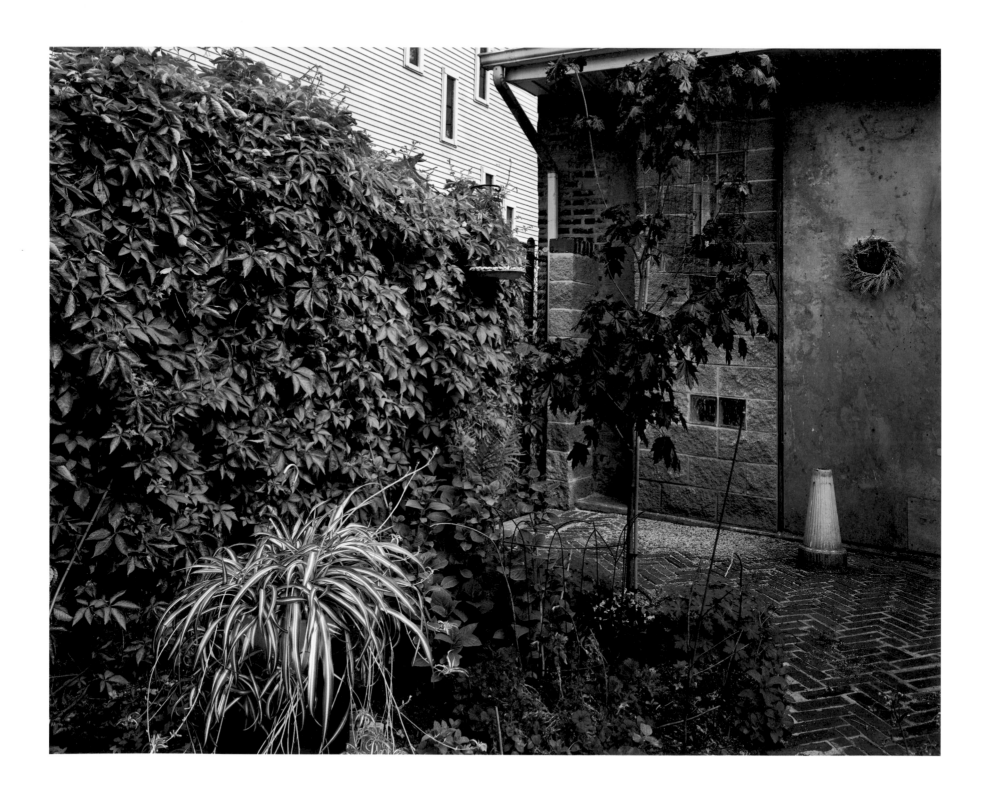

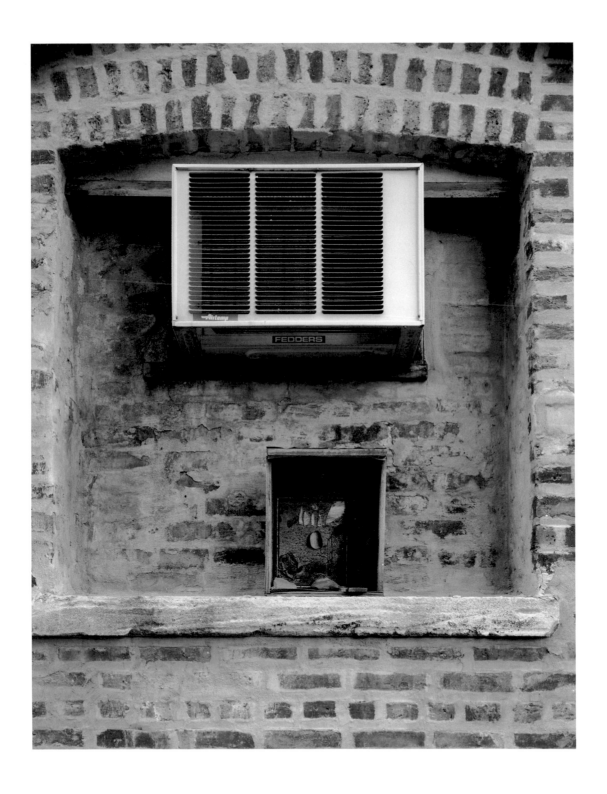

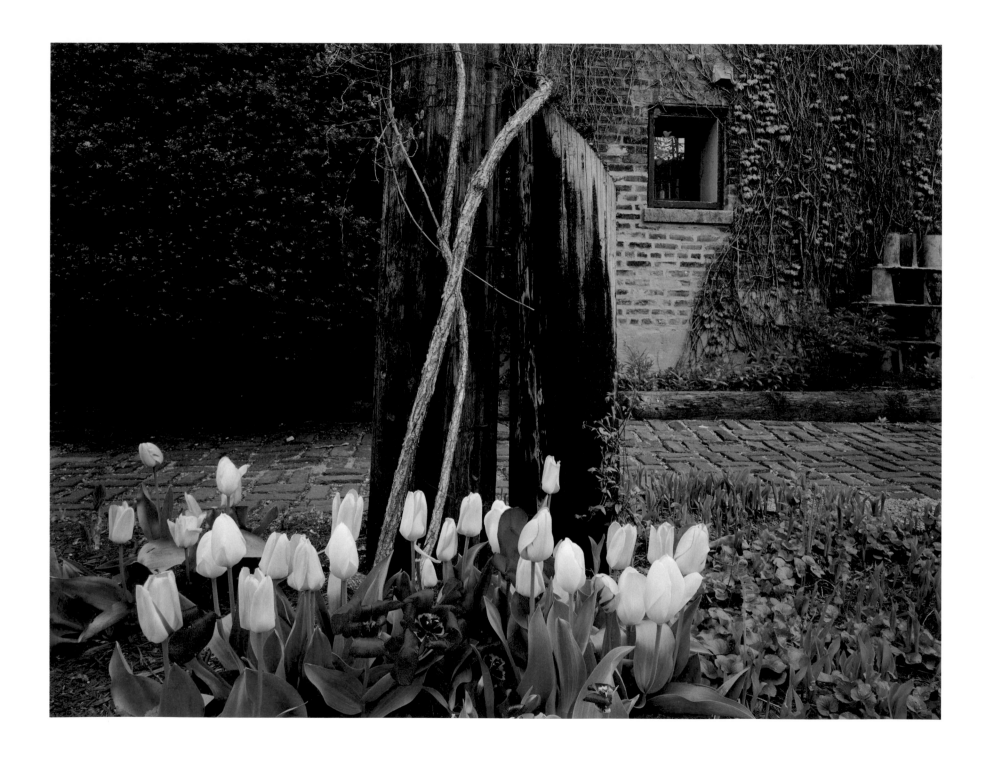

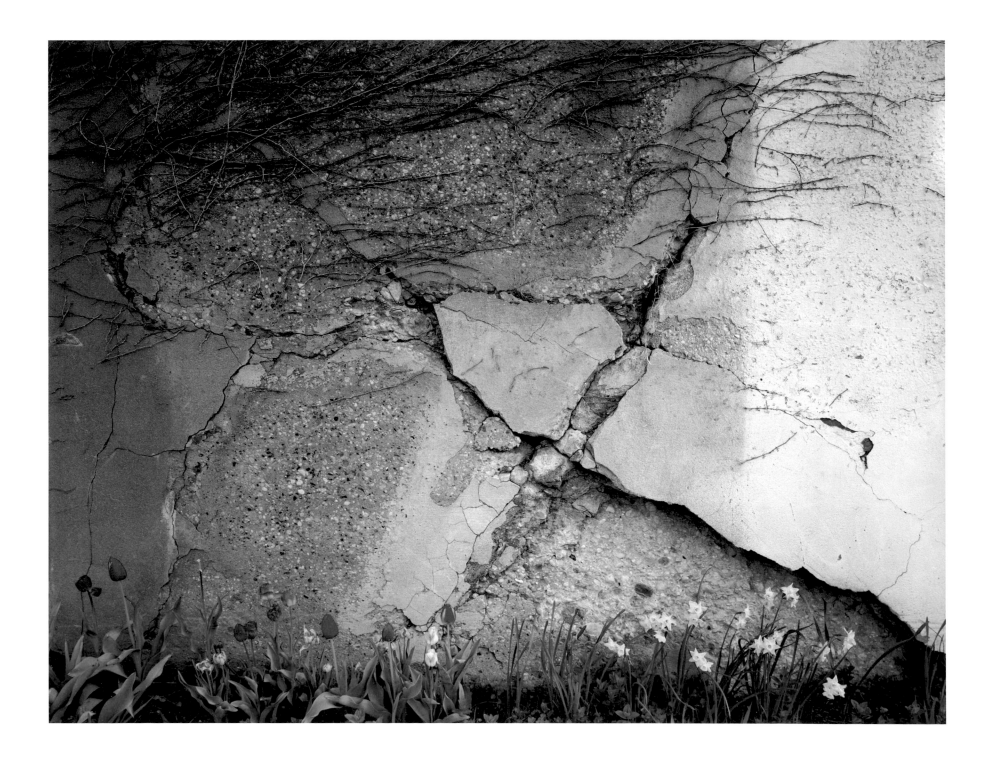

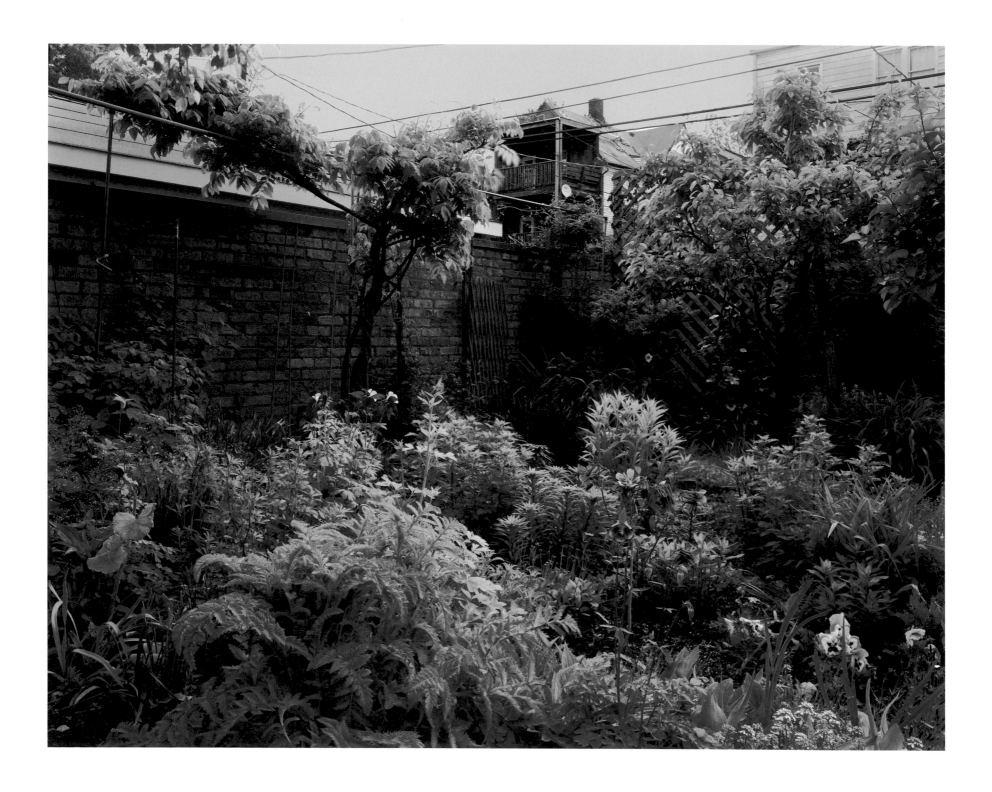

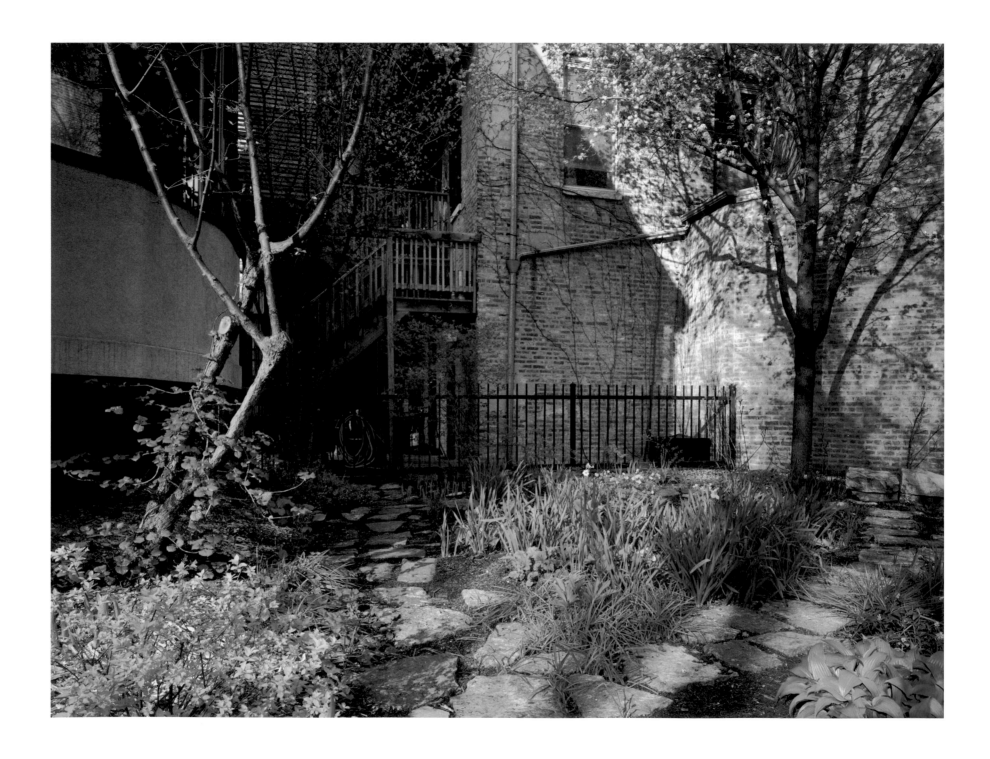

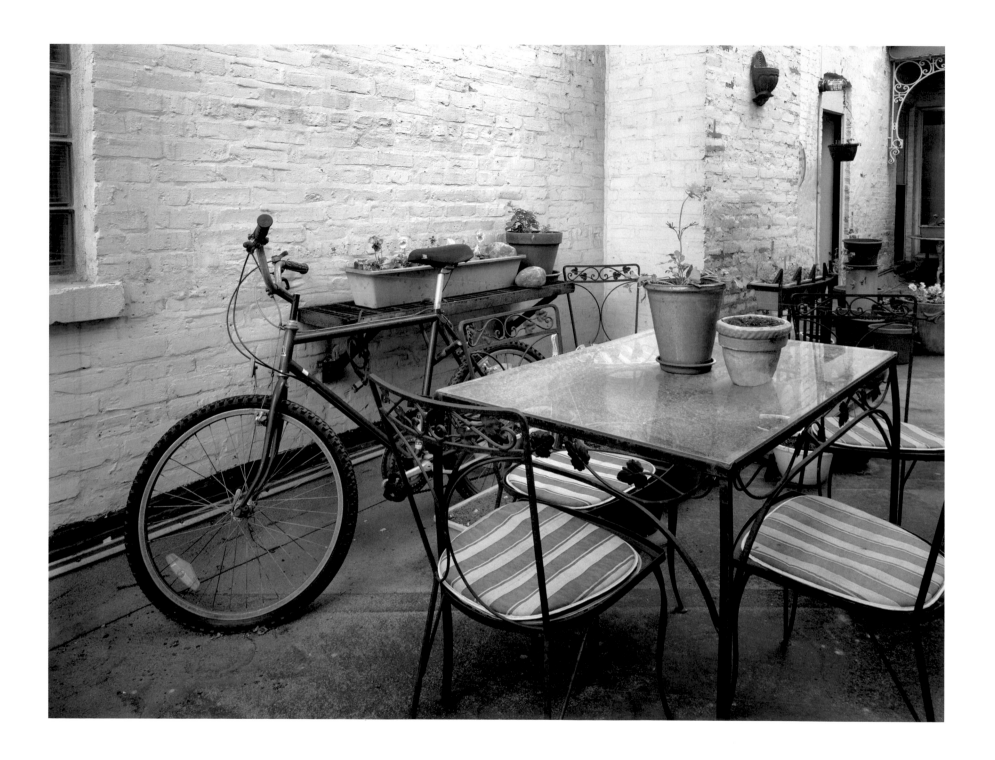

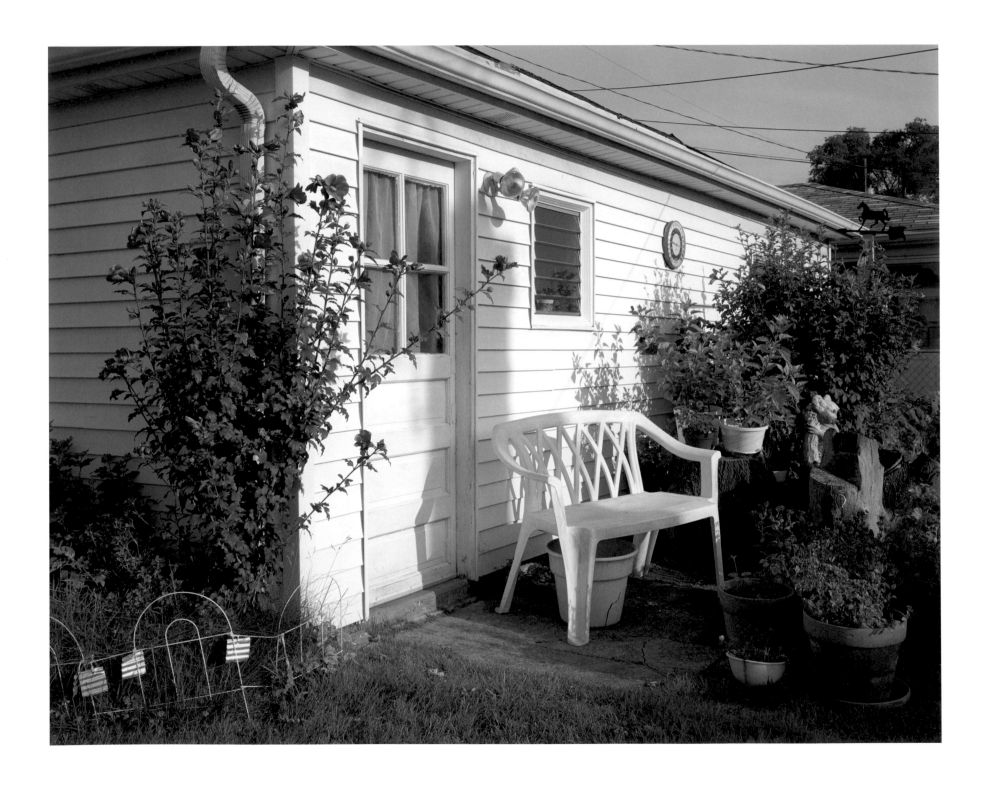

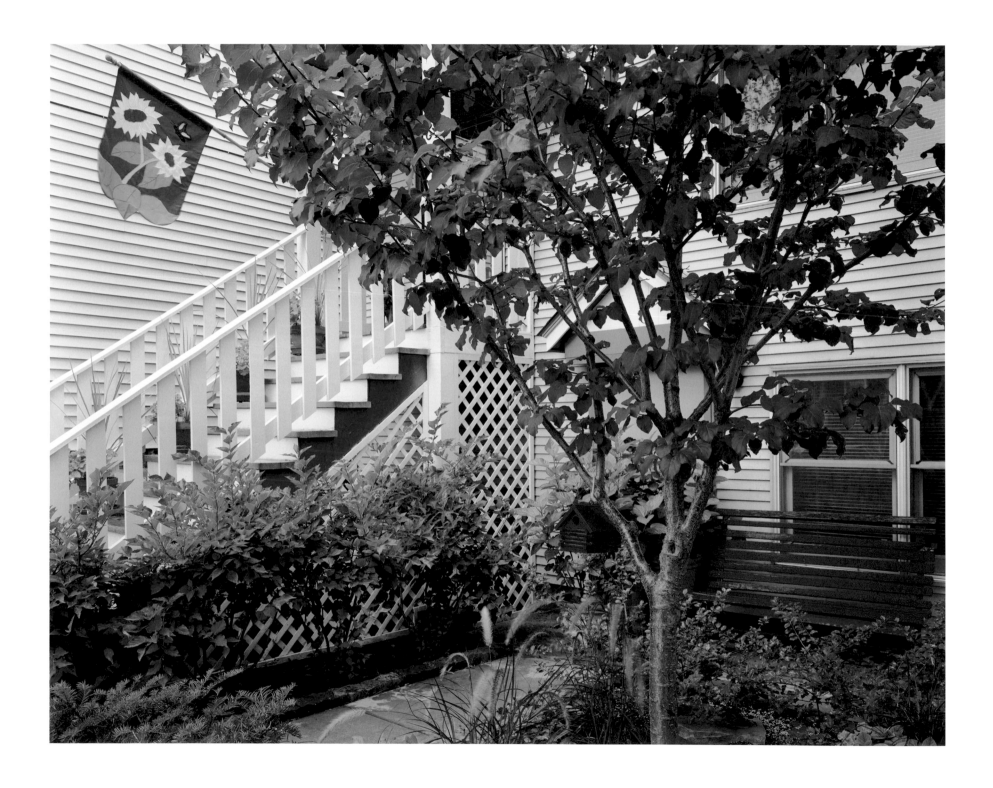

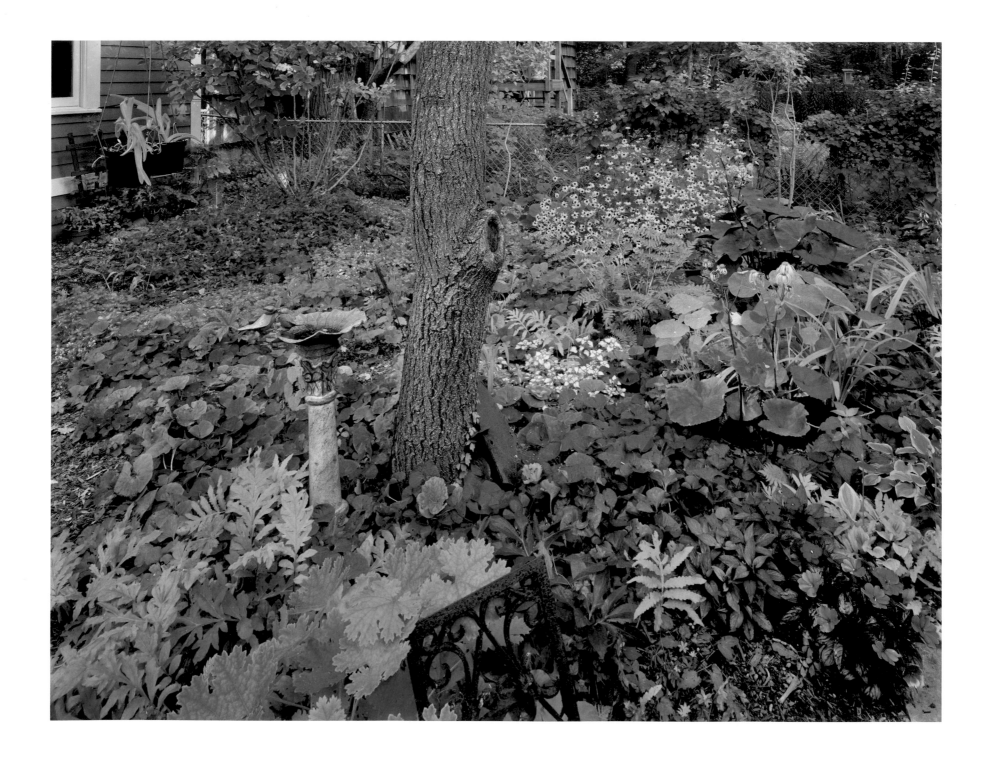

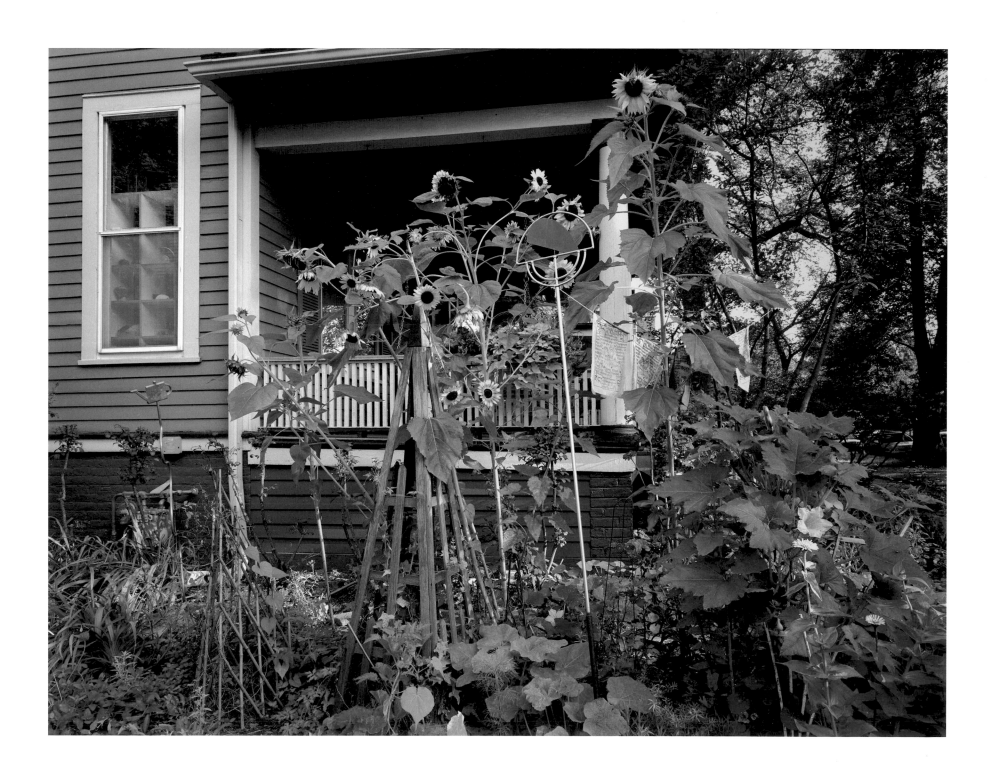

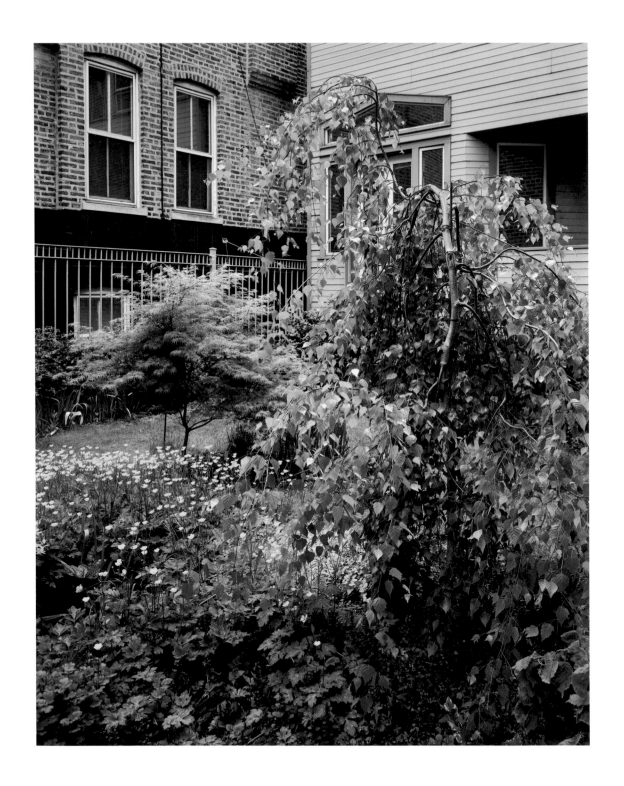

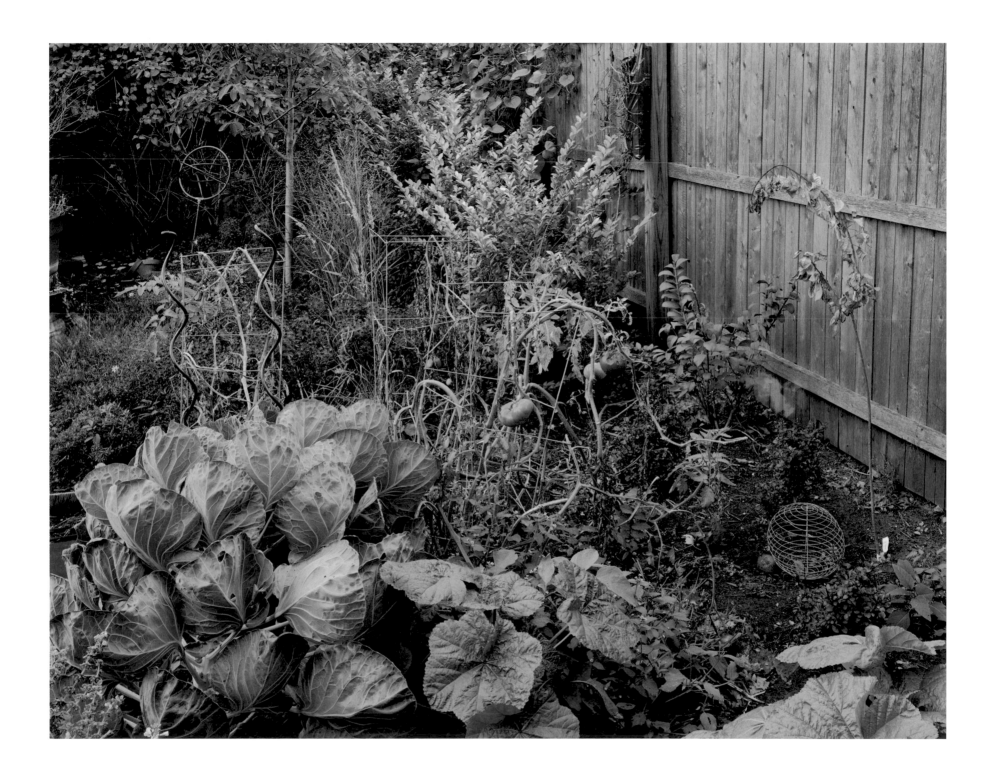

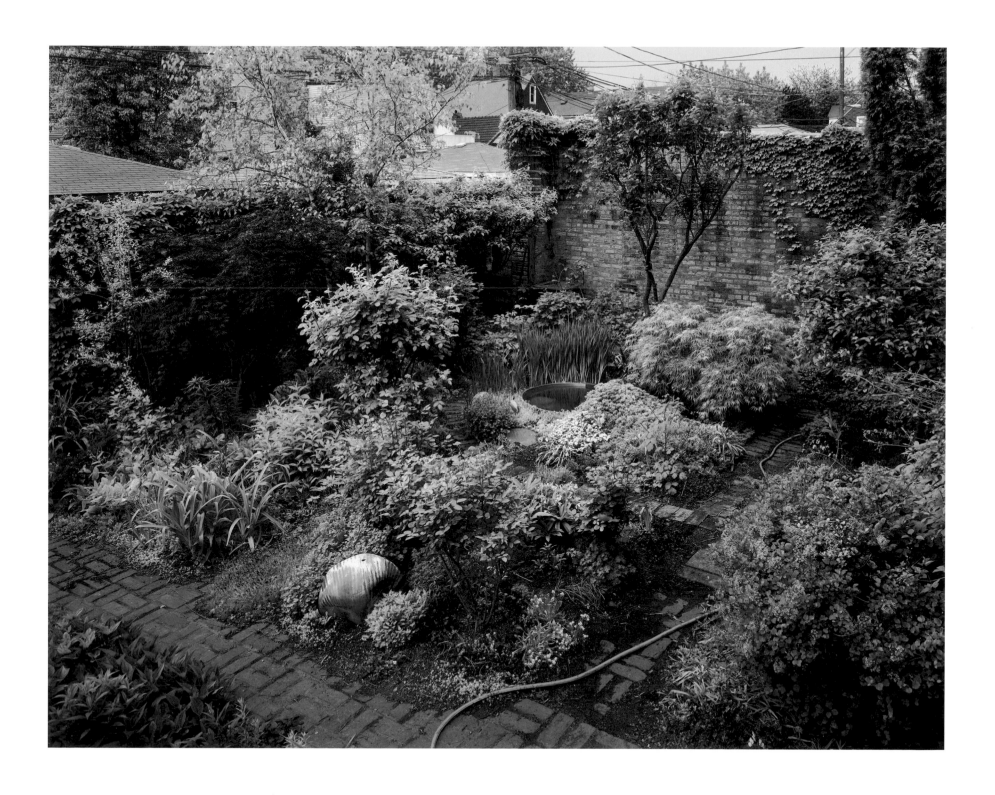

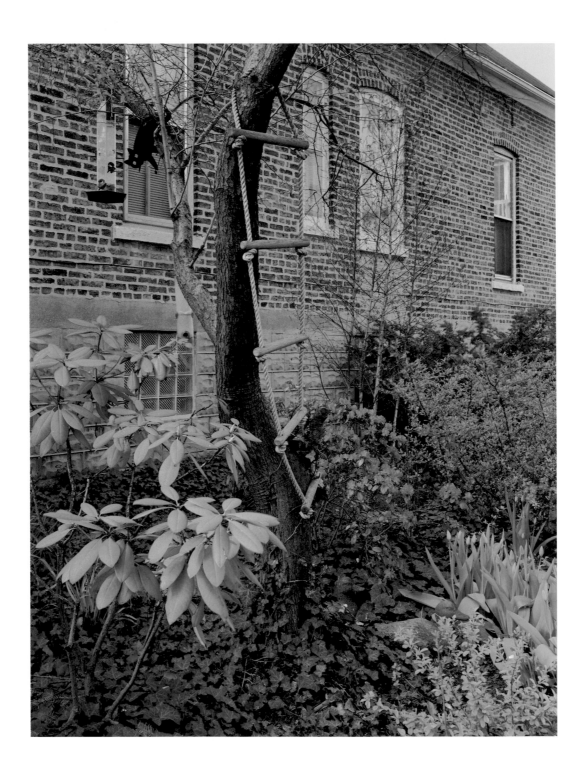

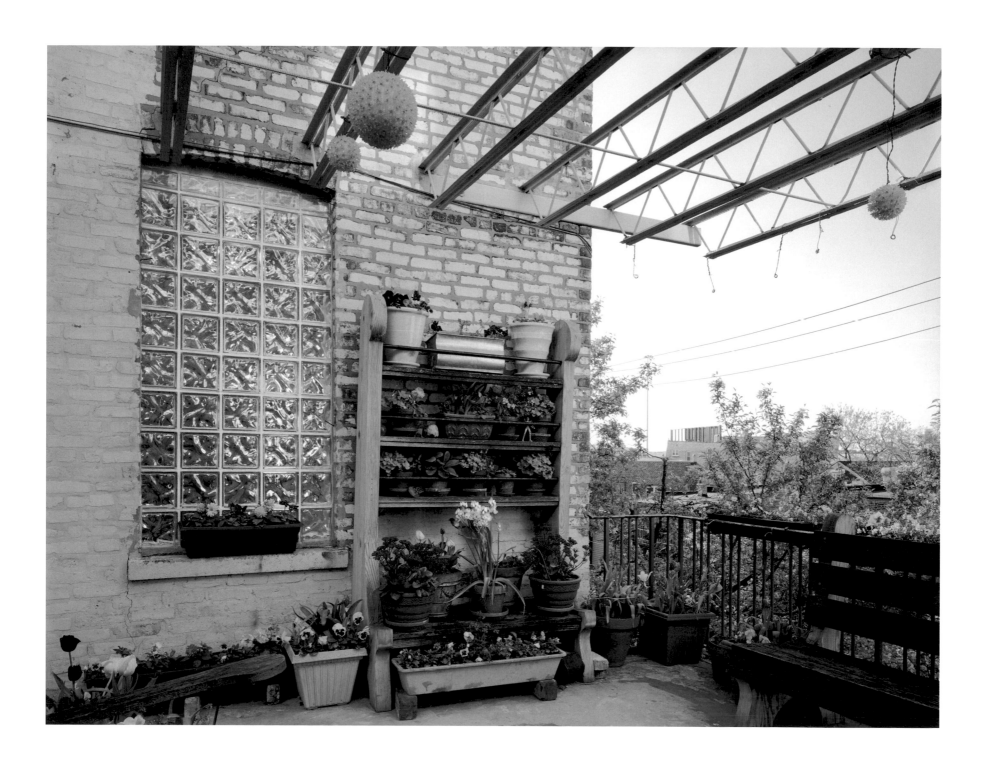

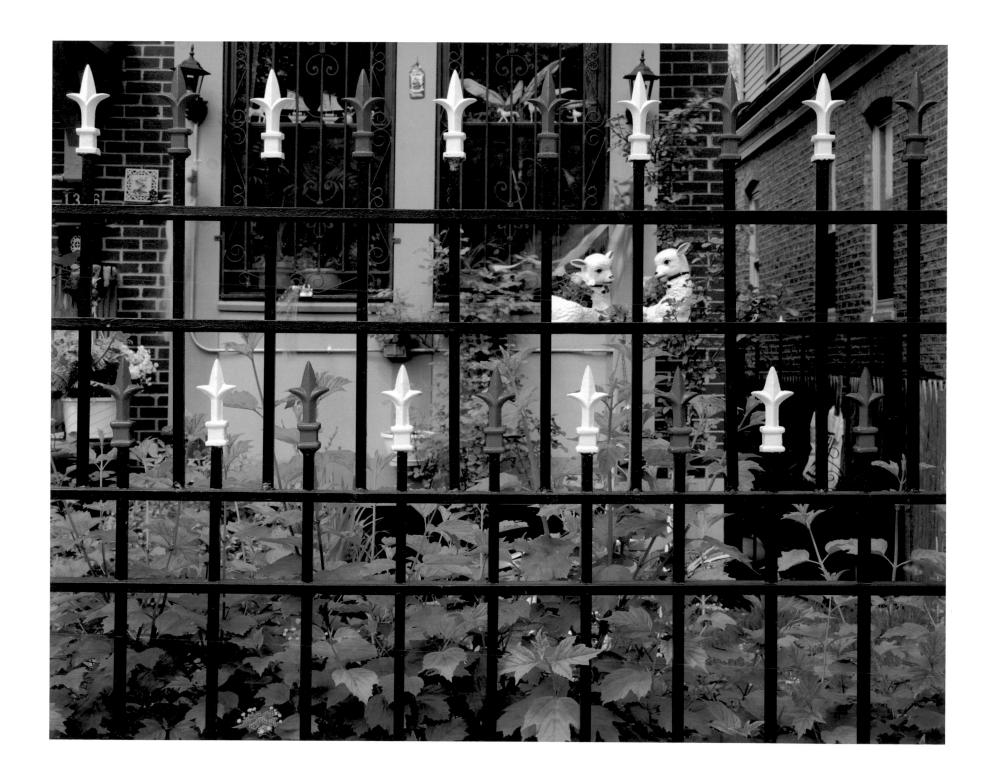

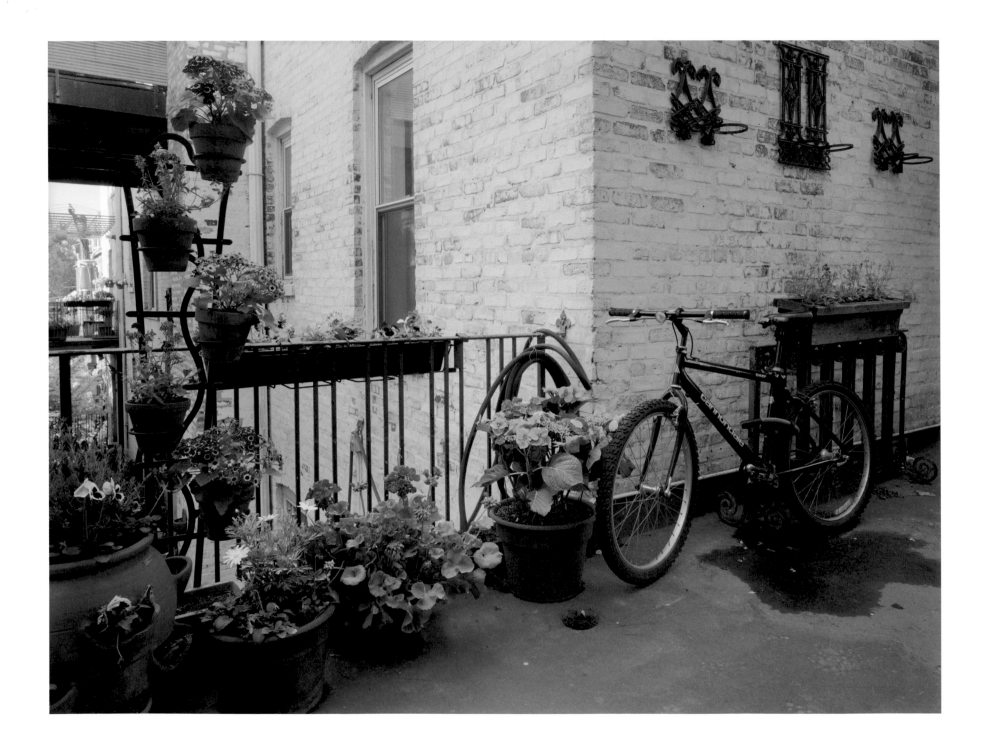

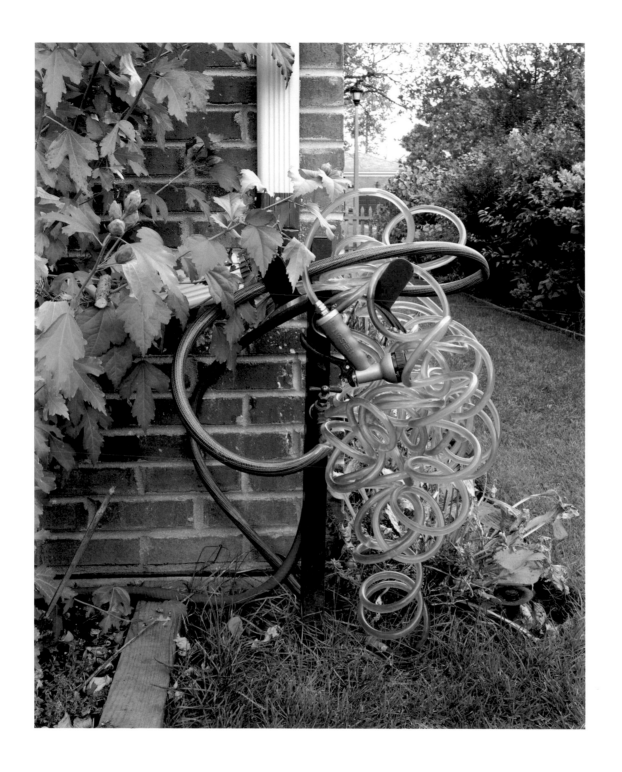

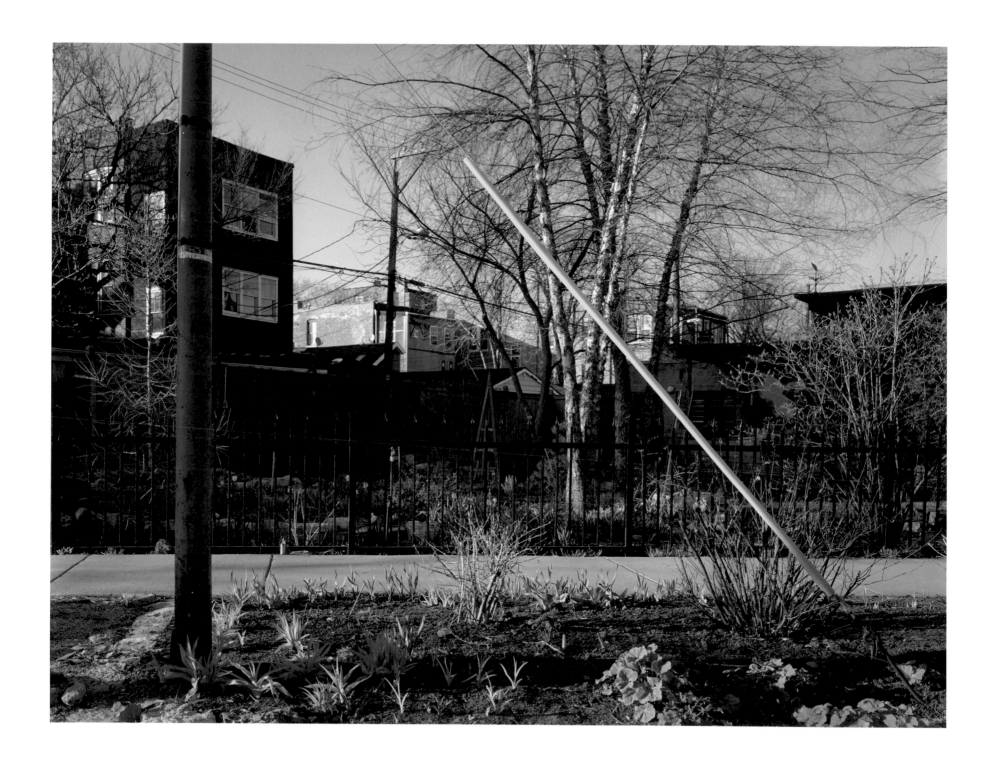

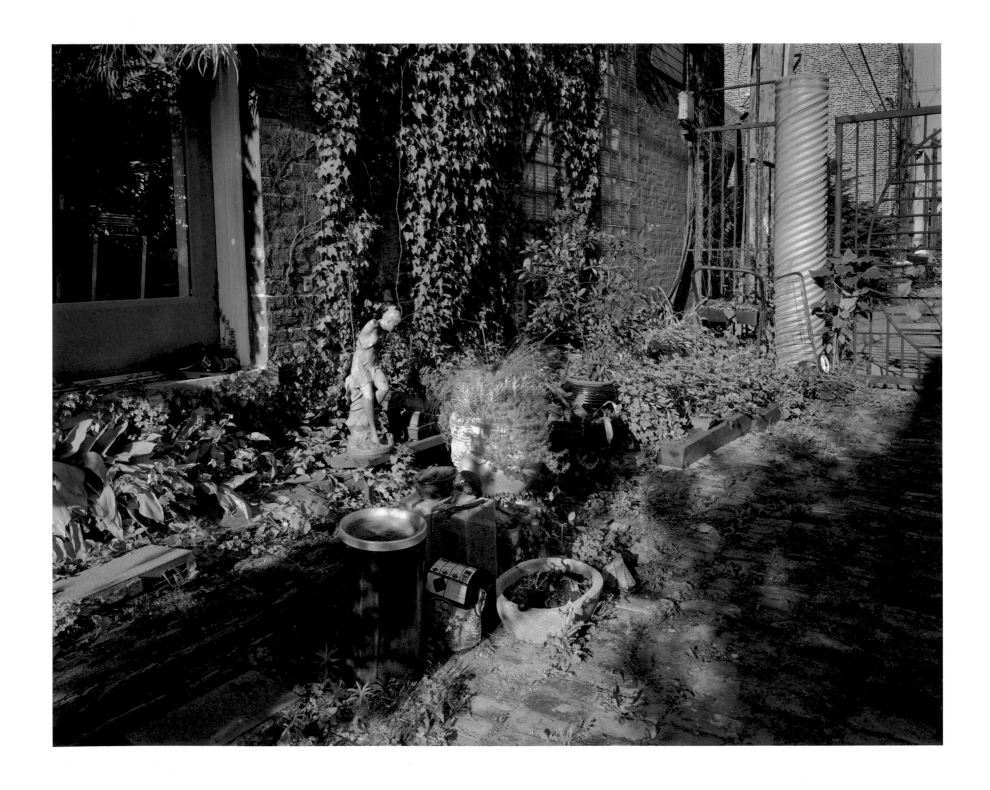

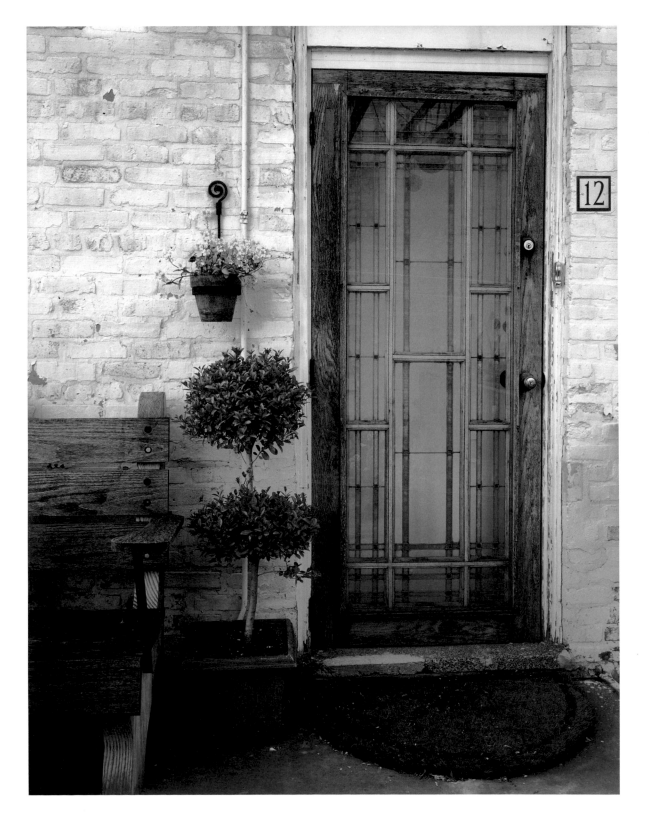

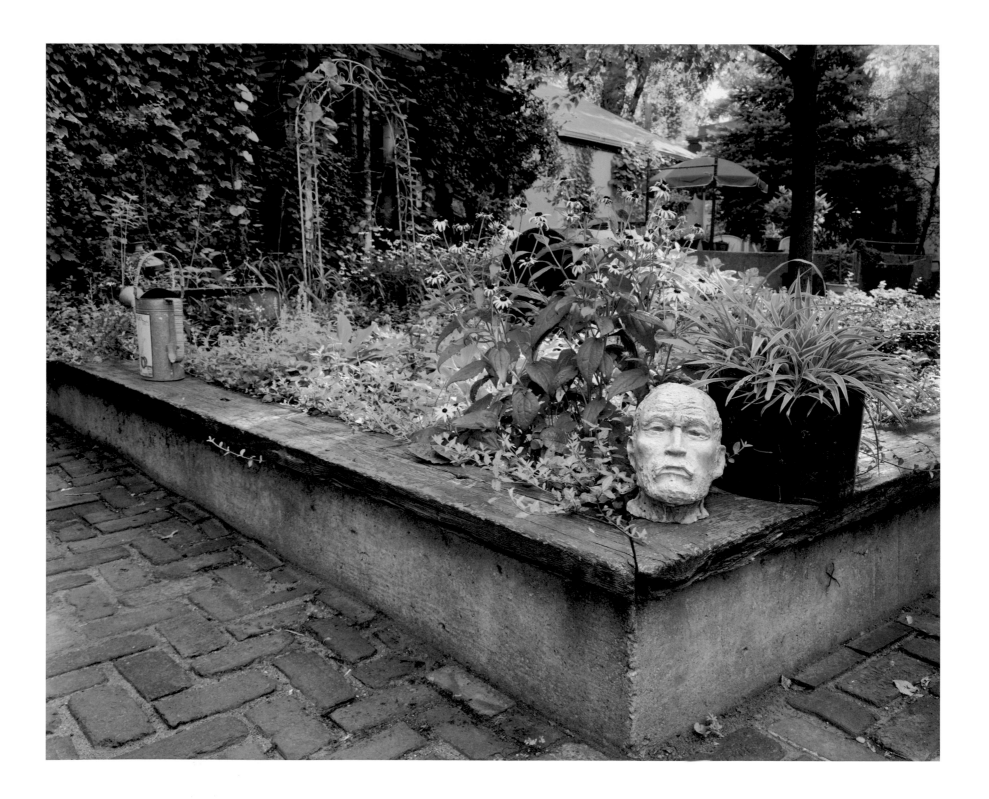

Afterword

I FIRST TOOK AN INTEREST IN GARDENING in the 1980s. My wife and I bought a house and we began researching gardens. We often marveled at other gardens we saw. After visiting several gardens around the United States and in Canada, we began to learn the names of plants and why certain flowers and shrubs lived well together and others didn't . . . how some gardens were like rooms and others were side notes.

I experienced different realities from being in different kinds of gardens; some of them were simply about beauty and stimulated my senses; others were calming, allowing me to relax; others were introspective. I became curious as to how gardens were planned. I listened to gardeners speak about their gardens and watched how they– the garden and gardener—would evolve. The gardeners were looking at a larger picture as if they were going through the same process as I do when making photographs. I felt a true *simpatico* with them.

I produced my first color photographs of gardens in the Annapolis Valley of Nova Scotia in 1988 (page 61). I continued photographing in color throughout the 1990s as I made other images of gardens in the United States, Turkey, Ireland, and France. I am attracted to small, intimate, and private gardens, rather than large public gardens. Small gardens have bits and pieces of the people who own them: found objects that are dear to them, keepsakes, statues, and personal items that reveal the people behind them. These gardens are for their creators' own adornment.

When entering a garden, I am first drawn to the color and then the organized space or

spaces of the garden, and to how things relate within. I find the use of space to be curious, and I pay attention to how the color affects that space as it transforms my own reality. Hence, the conversation begins. By being mindful of how I feel when making the picture, the photograph reveals something about me. How I choose to look at the space shows me how I organize my own life.

I believe that what one "sees" is no accident and is directly influenced by one's experiences. I subscribe to and use pre-visualization and the zone system, and I feel that the "life" of the photograph is most important. When photographing, I often know what I want in the final print—where values and colors should fall and the things I need to do to manipulate them. The final interpretation, however, determines the clarity of my idea. I use tools such as masking, contrast, and saturation, as well as burning and dodging, to change the relationship of values with each other. I learned that by manipulating the color-coupling agents in the negative to give me the extra saturation I desire, and by using digital technology, I am able to overcome any obstacles I find in the color process, yet stay true to my own ideas and background as a traditional black-and-white photographer.

I intend for these images to reveal gardens as a place of refuge, a place where one can read, meditate, and relax. They are places of beauty. When experiencing a garden, one brings associations and moments to it. Therefore, gardens become metaphors . . . private places one goes to. These private places encourage shared moments between the viewer and the photographs as well as the people behind the gardens. I "push" and exaggerate certain colors in order to lead the viewer; the colors become hyper-real, changing these gardens into magical places . . . allowing the viewer to enter the space and inviting them to escape into their own mind.

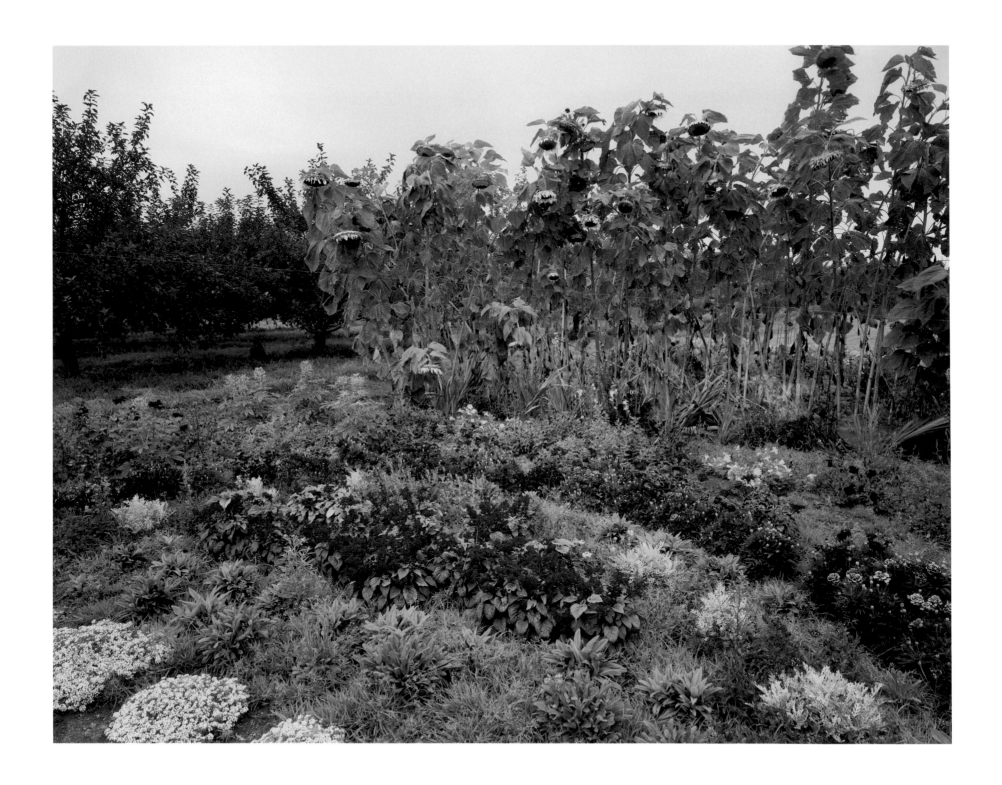

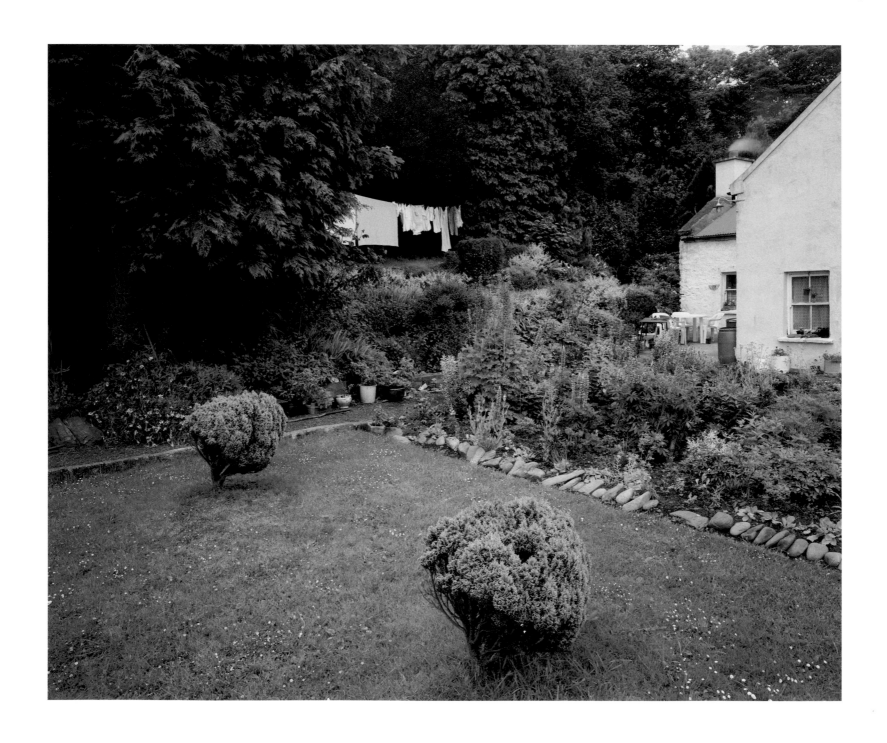

Acknowledgments

THE JOURNEY IS ALWAYS the most interesting part of the creative process, and the photographs I make remind me of things I learn on the way. When first making these pictures, I never envisioned the impact they would have on me. Throughout this project, I have been fortunate enough to meet and develop friendships with people who allowed me access into their private places. My deepest gratitude goes to Jane Wenger, whose excitement for the project and love for gardening were the catalysts that introduced me to many people and their gardens. I extend thanks to those who let me into their homes, gave me keys, and allowed me to "creep" around their property at uncivilized hours. Some of those include Roberta Temkin, Ruth Duckworth, Larry and Linda Lang, and John and Ann Podmajersky. I also thank Rich Cahan, who was responsible for involving me in the *CITY 2000* project. Several of these images came from that body of work.

I am most grateful for the financial support of Patrick and Susan Frangella. Their generosity and kindness made this book possible. I also thank Joan Morgenstern for her friendship and support of my work. The late David Ruttenberg, the first photography collector to buy my work, supported and encouraged me. I will always be grateful for this.

I thank Bob Thall, chairman of the Photography Department at Columbia College Chicago, for his support of this project. It was Bob who brought this project to the attention of George F. Thompson, president and publisher of the Center for American Places. George, your skill in sequencing the images and insight to the spirit of this work brings it to a new place.

Many thanks are due the other members of the team: to David Skolkin for his commitment to creating a beautiful design, and also for his patience; to Ben Gest for his essential work in translating my digital files for press; to Christine DiThomas for her invaluable copyediting; to Amber K. Lautigar for her assistance as the Center's publishing liaison; and to Steini Torfason and his colleagues at Oddi Printing for their professionalism and high calibre of work.

Columbia College Chicago provided institutional support for this project, and I extend my thanks to Dr. Warrick Carter, President; Steven Kapelke, Provost; Leonard Lehrer, Dean of the School of Fine and Performing Arts; and Michael DeSalle, Chief Financial Officer. Over the years, many friends, colleagues, and students at Columbia College have left their mark on me. I am especially grateful to them all.

It is a privilege to know Rod Slemmons, and I am deeply grateful for his friendship, counsel, and thoughtful essay. I also extend thanks to Natasha Egan, Karen Irvine, Stephanie Conaway, Corinne Rose, and the entire staff at the Museum of Contemporary Photography. They are a vital force in contemporary photography, and their support of photographers never ceases.

I first met David Adamson through his work with Jim Dine and other artists, and I contacted him to see about the possibility of working together. Our working relationship soon turned into a great friendship, and I am still in awe of his critical eye and abilities as a printmaker.

Honest criticism is always welcome, and I am lucky to know Colin Westerbeck, Anne Tucker, Andy Grundberg, Barbara Tannenbaum, Gary Chassman, Roy Flukinger, Linda Benedict-Jones, Elizabeth Siegel, David Travis, Evgeny Berezner, Irina Tchmyreva, Philip Brookman, and John Bennette, all of whom provided guidance and encouragement. I also thank Stephen Bulger, Scott Nichols, Ben Breard, June Bateman, Stephen Daiter, and Paul Berlanga for their early and ongoing commitment to my work.

There are those who make an impact on one's life. My first photography teacher, David Currie, changed my life. His positive reinforcement made me first fall in love with photography. Arthur Lazar and Joseph Jachna have been role models that exemplify the notion of living and working from the inside out and outside in. My friendship to John Chakeres is a gift; our discussions about art, photography, food, and life fill the in-betweens. I am grateful to Steve Fukawa,

Marilyn Castro, and Ira Schwartz for their truthfulness and deep friendship. I also thank Wayne and Teri Bonomo for their open acceptance and Jamey Sussman for his heart. I am deeply grateful on a daily basis to my parents, Gene Temkin and Beverly Temkin-Zeldin, as well as my sisters, Abbe Temkin and Tamara Baucom. My family continues to stand by my eccentricity. I also acknowledge my second family in Ireland, Betty and Francine Timmerman, avid gardeners who always encourage my growth.

My deepest love goes to my wife, Joyce Shatney, and our daughter, Mia. You have accepted me for who I am and supported all aspects of me. I realize this is an exceptionally hard thing to do, and my life would not have had the depth it has if it were not for you. I am glad to have you share this garden with me as it continues to bloom.

About the Author and the Essayist

BRAD TEMKIN was born in Chicago in 1956 and was raised in Wilmette, Illinois. His interest in music led him to begin making photographs in 1973. Although his early work began with music industry clients such as Mercury Records, Warner Electra Atlantic, *Creem* magazine, and several rock promoters, his focus quickly changed when he began to photograph other subjects, including landscape and portraiture, finding poetry in the world around him. Temkin received his B.F.A. in photography from Ohio University in 1979 and an M.F.A. in photography from the University of Illinois at Chicago in 1981. His photographs have been widely exhibited throughout the United States and abroad, and they are part of numerous permanent collections, including the Art Institute of Chicago, Krannert Art Museum in Champaign, Illinois, Museum of Contemporary Photography in Chicago, and Museum of Fine Arts in Houston, among others. His photographs have appeared in such publications as *Aperture, Black & White Magazine, Grateful Dead: An Illustrated Trip,* and *Strength From Unity: Expressions On Cancer.* Brad Temkin has taught photography at Columbia College Chicago since 1984, and he teaches workshops in Ireland each year. He currently resides in Skokie, Illinois, with his wife and daughter.

ROD SLEMMONS became Director of the Museum of Contemporary Photography in Chicago in 2002. From 1982 to 1996 he was Curator of Prints and Photographs at the Seattle Art Museum and from 1996 to 2002 was Director of the Museum at the University of Washington in Seattle. Mr. Slemmons was the national chairperson for the Society for Photographic Education from 1990 to 1994, and he has served for many years as a peer review panelist for the National Endowment for the Arts and as a grant reader and site evaluator for the National Endowment for the Humanities. He has organized numerous international traveling exhibitions, including *Diane Arbus* (1986); *Like a One-Eyed Cat* (1989), a thirty-year retrospective of photography by Lee Friedlander; *Shadowy Evidence: The Art of E. S. Curtis and His Contemporaries* (1989); and *Persistence of Vision* (2003), a retrospective of the digital work of Paul Berger. Mr. Slemmons's essays and reviews have appeared in dozens of publications, including *Afterimage, BlackFlash, Image,* and *Reflex.* He resides in Chicago.

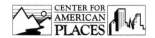

The Center for American Places is a tax-exempt 501(c)(3) nonprofit organization, founded in 1990, whose educational mission is to enhance the public's understanding of, appreciation for, and affection for the natural and built environment. Underpinning this mission is the belief that books provide an indispensable foundation for comprehending and caring for the places where we live, work, and explore. Books live. Books endure. Books make a difference. Books are gifts to civilization.

With offices in Santa Fe, New Mexico, and Staunton, Virginia, Center editors bring to publication as many as thirty books per year under the Center's own imprint or in association with publishing partners. The Center is also engaged in numerous other programs that emphasize the interpretation of place through art, literature, scholarship, exhibitions, and field research. The Center's Cotton Mather Library in Arthur, Nebraska, its Martha A. Strawn Photographic Library in Davidson, North Carolina, and a ten-acre reserve along the Santa Fe River in Florida are available as retreats upon request. The Center is also affiliated with the Rocky Mountain Land Library in Colorado.

The Center strives every day to make a difference through books, research, and education. For more information, please send inquiries to P.O. Box 23225, Santa Fe, NM 87502, U.S.A., or visit the Center's Website (www.americanplaces.org).

ABOUT THE BOOK:

The text for *Private Places: Photographs of Chicago Gardens* was set in Aldus. The paper is acid-free Silk Gallery, 170 gsm weight. The four-color separations, printing, and binding were professionally rendered by Oddi Printing Ltd., of Reykjavik, Iceland. *Private Places* was published in association with the Photography Department at Columbia College Chicago, which is one of the nation's largest and most prestigious photography programs. For more information, visit online at: www.colum.edu/undergraduate/photo.

FOR THE CENTER FOR AMERICAN PLACES:

George F. Thompson, *President and Publisher*
Amber K. Lautigar, *Publishing Liaison and Assistant Editor*
Ernest L. Toney, Jr., *Chelsea Miller Goin Intern*
Rebecca A. Marks, *Production and Publicity Assistant*
David Skolkin, *Book Designer and Art Director*
David Adamson, *Printmaker*

FOR COLUMBIA COLLEGE CHICAGO:

Christine DiThomas, *Manuscript Editor*
Mary Johnson, *Director of Creative and Printing Services*
Benjamin Gest, *Director of Digital Scans*
Tammy Mercure, *Digital Imaging Facilities Coordinator*
Thomas Shirley, *Coordinator of Digital Imaging*
Bob Thall, *Chairman, Photography Department*

Rod Slemmons became Director of the Museum of Contemporary Photography in Chicago in 2002. From 1982 to 1996 he was Curator of Prints and Photographs at the Seattle Art Museum and from 1996 to 2002 was Director of the Museum at the University of Washington in Seattle. Mr. Slemmons was the national chairperson for the Society for Photographic Education from 1990 to 1994, and he has served for many years as a peer review panelist for the National Endowment for the Arts and as a grant reader and site evaluator for the National Endowment for the Humanities. He has organized numerous international traveling exhibitions, including *Diane Arbus* (1986); *Like a One-Eyed Cat* (1989), a thirty-year retrospective of photography by Lee Friedlander; *Shadowy Evidence: The Art of E. S. Curtis and His Contemporaries* (1989); and *Persistence of Vision* (2003), a retrospective of the digital work of Paul Berger. Mr. Slemmons's essays and reviews have appeared in dozens of publications, including *Afterimage, BlackFlash, Image*, and *Reflex*. He resides in Chicago.

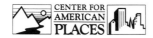

The Center for American Places is a tax-exempt 501(c)(3) nonprofit organization, founded in 1990, whose educational mission is to enhance the public's understanding of, appreciation for, and affection for the natural and built environment. Underpinning this mission is the belief that books provide an indispensable foundation for comprehending and caring for the places where we live, work, and explore. Books live. Books endure. Books make a difference. Books are gifts to civilization.

With offices in Santa Fe, New Mexico, and Staunton, Virginia, Center editors bring to publication as many as thirty books per year under the Center's own imprint or in association with publishing partners. The Center is also engaged in numerous other programs that emphasize the interpretation of place through art, literature, scholarship, exhibitions, and field research. The Center's Cotton Mather Library in Arthur, Nebraska, its Martha A. Strawn Photographic Library in Davidson, North Carolina, and a ten-acre reserve along the Santa Fe River in Florida are available as retreats upon request. The Center is also affiliated with the Rocky Mountain Land Library in Colorado.

The Center strives every day to make a difference through books, research, and education. For more information, please send inquiries to P.O. Box 23225, Santa Fe, NM 87502, U.S.A., or visit the Center's Website (www.americanplaces.org).

ABOUT THE BOOK:
The text for *Private Places: Photographs of Chicago Gardens* was set in Aldus. The paper is acid-free Silk Gallery, 170 gsm weight. The four-color separations, printing, and binding were professionally rendered by Oddi Printing Ltd., of Reykjavik, Iceland. *Private Places* was published in association with the Photography Department at Columbia College Chicago, which is one of the nation's largest and most prestigious photography programs. For more information, visit online at: www.colum.edu/undergraduate/photo.

FOR THE CENTER FOR AMERICAN PLACES:
George F. Thompson, *President and Publisher*
Amber K. Lautigar, *Publishing Liaison and Assistant Editor*
Ernest L. Toney, Jr., *Chelsea Miller Goin Intern*
Rebecca A. Marks, *Production and Publicity Assistant*
David Skolkin, *Book Designer and Art Director*
David Adamson, *Printmaker*

FOR COLUMBIA COLLEGE CHICAGO:
Christine DiThomas, *Manuscript Editor*
Mary Johnson, *Director of Creative and Printing Services*
Benjamin Gest, *Director of Digital Scans*
Tammy Mercure, *Digital Imaging Facilities Coordinator*
Thomas Shirley, *Coordinator of Digital Imaging*
Bob Thall, *Chairman, Photography Department*